SECRET LICHFIELD

Neil Coley

AMBERLEY

First published 2018

Amberley Publishing
The Hill, Stroud
Gloucestershire, GL5 4EP

www.amberley-books.com

Copyright © Neil Coley, 2018

The right of Neil Coley to be identified as the Author
of this work has been asserted in accordance with
the Copyrights, Designs and Patents Act 1988.

ISBN 978 1 4456 8209 9 (print)
ISBN 978 1 4456 8210 5 (ebook)

British Library Cataloguing in Publication Data.
A catalogue record for this book is available from the
British Library.

Origination by Amberley Publishing.
Printed in Great Britain.

Contents

Introduction

For a long time the history of Lichfield has fascinated myself and many other local writers. In particular I have developed an interest in the lesser-known aspects of the city's past and those people and events that have, for a variety of reasons, been ignored or forgotten over the years. As a result it has been a pleasure to research and write this book and to attempt to uncover some of the more unusual aspects of this beautiful city of Lichfield and the people who have lived here.

The origin of the name Lichfield has engendered controversy over the years. For many, including the city's most famous son, Samuel Johnson, it meant 'field of the dead', a reference to the legend that the area was once the scene of a fourth-century massacre of persecuted Christians during the reign of the Roman Emperor Diocletian. The Roman army certainly built a military settlement, which they called Letocetum, around a mile from where Lichfield now stands, but there is no evidence to support the 'massacre' story and so today this explanation of the origin of the city's name is considered apocryphal. However, the legend is compelling enough for one of the city's crests to include the image of three dead bodies with weapons lying close by. These days it is generally believed that the place name Lichfield is actually made up of the Celtic word 'lyccid', meaning 'grey wood', and the Anglo-Saxon term 'feld', meaning 'open land'.

Over the centuries, in its long and rich history, the small Staffordshire city of Lichfield has seen many strange and unusual events. There were, for example, the tumultuous and bloody Civil War sieges of the seventeenth century, during which the cathedral was bombarded with cannonballs and a top army general was shot dead in a city street. There were the years during which Lichfield was an important coaching city, when stagecoach accidents were common and highwaymen often terrorised the surrounding area. Stories abound of dire punishments inflicted in Lichfield's market square when individuals were burned to death at the stake and others were flogged to within an inch of their lives before being put on display in the city's pillory. An army garrison town from the eighteenth century, Lichfield had many beerhouses and taverns servicing the drinking needs of billeted red-coated soldiers and where houses of ill repute saw to their other, less savoury requirements. With so many ancient buildings it is little wonder that stories of ghostly occurrences have grown up, with everything from a laughing cavalier haunting a city street to a crying, supernatural baby keeping people from their night-time slumbers.

Secret Lichfield will hopefully enable the reader to discover some of the more unusual events that have occurred in this seemingly peaceful place and will also help to examine the lives of the eccentric, and in some cases downright weird, individuals who have lived in the city over the years and the strange incidents associated with them.

1. Travel and Transport

These days it is not widely remembered that on New Year's Day 1946 a disastrous and tragic rail accident occurred at Lichfield. The incident took place at 6.58 in the evening when the fish train travelling from Fleetwood to London ran into a passenger train that was waiting at Lichfield's Trent Valley station. The last three carriages of the Nuneaton to Stafford passenger train were destroyed and the engine itself was pushed 100 yards up the track. Twenty people were killed and many others injured in the accident, including some military personal returning from their Christmas leave. A government report later in the year found that the accident was the result of points being frozen in the bitterly cold weather and the goods train mistakenly being routed on to the same line as the local train. Rather incongruously the Reverend Awdry, the writer of the *Thomas the Tank Engine* books, used this real life event as the basis of one of his railway stories, *The Flying Kipper.*

The history of unfortunate Lichfield-based New Year's transport accidents goes back a lot further than 1946. On 1st January 1830 a stagecoach, called *The Telegraph,* was heading for Lichfield when its driver was thrown off the vehicle and the horses bolted,

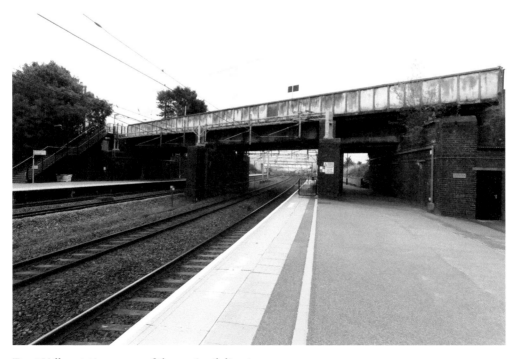

Trent Valley station, scene of the 1946 rail disaster.

at top speed, down Swinscoe Hill, just outside Ashbourne. At the bottom of the hill the coach hit the wall of a public house and then careered into a toll house, losing one of its wheels and ending up broken into pieces. The guard and two passengers managed to jump clear before the crash but another individual, who failed to get out in time, was seriously injured. *The Staffordshire Advertiser* later reported that the driver and the guard had been, 'far from sober' as they had called in at many of the inns along the way 'to drink in commemoration of the day'. A group of passengers at Lichfield's George Hotel, who were ready to board the coach, which was supposed to carry them on to Birmingham, had to wait until the following day before they could complete their journey.

DID YOU KNOW?
The coach fare between Birmingham and Lichfield in 1771 was 4s (20p). Coaches set out from the Castle Inn in High Street, Birmingham, at seven o'clock in the morning on Mondays, Wednesdays and Fridays, arriving at the Old Crown in Bore Street, Lichfield, and returning to Birmingham in the evening.

Being a member of the royal family did not stop you from becoming the victim of a coaching accident. In 1815 the Prince Regent, the future George IV, visited Lichfield before going on to Beaudesert Hall, the home of his friend the Marquis of Anglesey. At the George Inn in Bird Street a new team of horses were attached to the prince's coach ready for the journey to the hall a few miles out of the city. However, at the corner of Featherbed Lane the horses, according to the local newspaper, 'thrust the carriage into a ditch'. Luckily no one was hurt and after some repairs to the vehicle the prince was able to continue his journey.

A tragic coaching accident in 1728 rather spookily caused a strange prophecy to become true. Sir William Wolseley of Wolseley Hall near Lichfield was a great traveller. Once he was in Egypt where he purchased four magnificent Arab horses. He also decided to have his fortune told and was informed that his new horses would die by drowning. Understandably worried about the prophecy, he sent his four horses home by ship while he travelled back to Britain overland and was no doubt on tenterhooks as he crossed the English Channel. Once he had safely reached Lichfield he was convinced that the prophecy was wrong and so had his new horses hitched to his own coach and he set off back to his stately mansion. However, on the way an unusually fierce thunderstorm occurred and just as his coach was crossing a deep ford a nearby millpond dam burst its banks sending a torrent of water downstream. The coach was overturned and Sir William and his four horses were drowned. Only his servant, who had managed to cling to a tree, survived. One hundred years later a plate with the Wolseley coat of arms was found in the river.

Lichfield, on the main route between London and the North, was particularly important as a stopping-off point in the days of the stagecoach and, as a result there were many coaching inns in the city, such as the George, the Swan and the King's Head, which were all situated in Lichfield's Bird Street. Nearby, in Beacon Street, another coaching inn,

The George Hotel.

the Coach & Horses, was reputedly a haunt of the infamous highwayman Dick Turpin, who often plied his trade in the countryside around Lichfield and Cannock. Legend has it that in the 1730s Turpin was in love with a woman called Nance and would often visit her at the inn for night-time assignations. Legend also has it that Turpin's horse, Black Bess, would be left by the highwayman to happily graze in a nearby field. Turpin was not the only villain to frequent the Coach & Horses. Other highwaymen visited the inn and its landlady, Judith Jackson, a famous Lichfield beauty, actively encouraged their nefarious activities and gave them a 'safe house' in which to stay, no doubt in return for a share of their ill-gotten gains. Today the Coach & Horses is a private residence.

Lichfield also had its own 'home-grown' highwayman in the form of Jack Withers, the son of a city butcher. Withers travelled the country, ending up at one time in London's Newgate gaol for theft. Choosing the option of joining the army in order to avoid execution, he was posted to Ghent in Belgium. One day he was caught robbing a charity box in Ghent Cathedral but the quick-thinking thief avoided punishment by concocting a story about how the statue of the Virgin Mary had caused the box to fly open and instructed him to take the money to help the poor. The somewhat gullible authorities were so impressed by the silver-tongued Withers that they declared a miracle had taken place and paraded him in honour around the cathedral. Jack Withers' luck did not last, however. Back in Britain and operating as a highwayman in various locations he was eventually arrested, tried for the murder of one of his victims and hanged at Thetford in Norfolk in April 1703.

The former Coach & Horses Inn.

Withers was not the only home-grown murderous thief as, also in 1703, a criminal gang was spending its time busily robbing stagecoaches in the local area. In January of that year members of the gang stopped the Shrewsbury coach at Brownhills, relieving its occupants of their valuables, and then went on to rob two animal drovers, leaving one dead and the other seriously injured. Soon afterwards the gang attacked the High Sheriff of Staffordshire, who was travelling back from Lichfield with several of his servants. They stole 60 guineas and cut off the hand of one of the sheriff's servants. The Sheriff, with all the county's resources available to him, instituted a search for the criminals. When nine members of the gang were subsequently arrested it was discovered that three of the malefactors were woman.

DID YOU KNOW?
In October 1929 Lichfield residents were excited by the sight of the airship R101 flying over the city. The sighting took place as the massive airship was on its second test flight, flying from its base at Cardington to Derby at a height of 1,500 feet and at a speed of 60 mph. The R101 was intended to provide a service over long-distance routes throughout the Empire but just a year after its flight over Lichfield it crashed in France killing forty-eight of its passengers.

Other highwaymen were also continual threats on the unlit roads around the city. In January 1761, for example, on Whittington Heath, a single highwayman on a bay horse stopped several inhabitants of Lichfield, who were travelling back by coach from Tamworth market. From one passenger, Mr Gregory, a dyer, he took 9*d* and a silver coat button, from a Mr Henry he stole 9 or 10 shillings and took half a crown from a poor pie woman. Mr Broughton, an elderly man who sold linen cloth, escaped by galloping away, although his horse was loaded with goods. The highwayman fired a pistol at him but luckily missed.

The stagecoaches that ran from Lichfield often had grandiose and speedy sounding names in order to attract potential passengers. Examples included *The True Blue Alert* (which ran to Rugeley), *The Rapid* (to Derby) and *The Quicksilver* (to Shrewsbury). Coaches also provided a great deal of related employment in the city. As well as all the staff needed at coaching inns, stables needed to be staffed and there were also a number of coach makers in the city, individuals such as James Butler of Wade Street. Butler also provided a hearse and a mourning coach for funerals. However, by 1840 the stagecoach industry in the city had drastically declined causing an economic downturn in the local area. Things eventually improved with the coming of the railways to Lichfield and the opening of the city's two railway stations in 1847 and 1849.

Lichfield folk were excited to see what for many would have been their first sighting of an aeroplane in April 1910, when aviator Claude Grahame-White was forced to land his 'flying machine' due to an engine fault. He was taking part in the Manchester to London air race when he landed in a farmer's field close to the city. Grahame-White, while waiting for his plane to be fixed, was given a lift into the city centre and had lunch at the George Hotel. Meanwhile the local farmer wasted no time in charging people an admission fee to see the

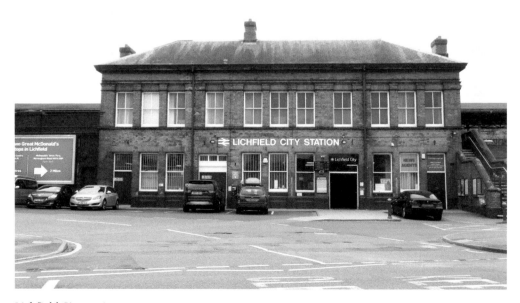

Lichfield City station.

aeroplane. When the pilot returned strong winds and heavy rain made it impossible for him to take off again and eventually Grahame-White's plane was dismantled and put on a flatbed truck and sent by train to London. The Manchester to London air race was the first of its kind and a prize of £10,000 was offered to the first pilot to complete the journey. Today a plaque on the side of the George Hotel commemorates the event.

Lichfield's connections to sea travel might at first seem rather unlikely but James Boswell, friend and biographer of Samuel Johnson, when visiting the city in 1776, was surprised to find a number of marine-based occupations being carried out in Lichfield, particularly the manufacture of sailcloth and streamers for ocean-going ships. Visitors to the city today are often equally intrigued to find a statue of Hanley-born Captain Edward Smith, skipper of RMS *Titanic*, in the Museum Gardens area of Beacon Park. For many years a myth circulated that the authorities in Hanley had originally ordered the statue but when *Titanic* sank in 1912 they refused to locate it in their town, thinking the whole matter was something of an embarrassment. It was a good story but in reality the statue was not commissioned until after the tragic demise of Captain Smith and his famous ship. In October 1913 a committee was set up to find a site for the memorial statue and in May 1914 a meeting took place between the committee and the mayor of Lichfield, Councillor R. Bridgeman. They decided that Lichfield, with its central location in Smith's home county of Staffordshire, would be a suitable place for the memorial to be situated. The 17-foot-high statue, sculpted by Kathleen Scott, widow of the Antarctic explorer Captain Robert Falcon Scott, was unveiled on 29 July 1914. Present at the unveiling were Smith's widow and daughter as well as representatives from Belfast, Liverpool and New York – all places with *Titanic* connections.

The railway bridge in Lichfield's Upper St John Street, in recent years, has all too often been struck by heavy goods vehicles travelling through the city centre, so much so that it has become the sixth most frequently struck bridge in the whole of the United Kingdom. The 'low' bridge is just over 14 metres high and despite being emblazoned with large and

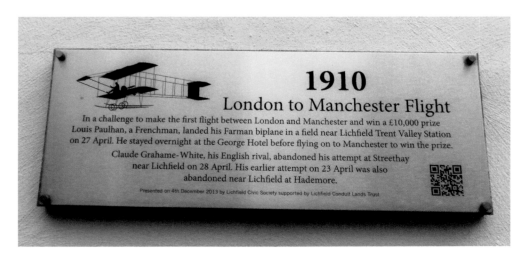

The George's plaque.

Captain Smith of the
RMS *Titanic*.

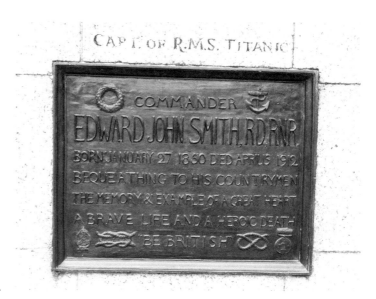

The Captain Smith plaque.

clear warnings to that effect it keeps being hit by lorries on a regular basis. Since 2009 there have been around ninety such events and the owners of the Bitter-Suite micropub, which is situated next to the bridge, recorded over thirty bridge hits in the pub's first six months of trading. Despite the traffic chaos caused by trucks wedged under the bridge the customers at the Bitter-Suite are quite happy when an incident occurs as the pub owners have decreed that every time the bridge gets hit patrons in the pub at the time will be served with a free half pint of the Bitter-Suite's own Bridge Strike Bitter!

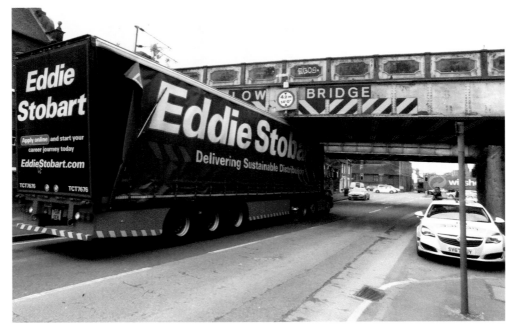

One of the many recent bridge strikes in Upper St John Street.

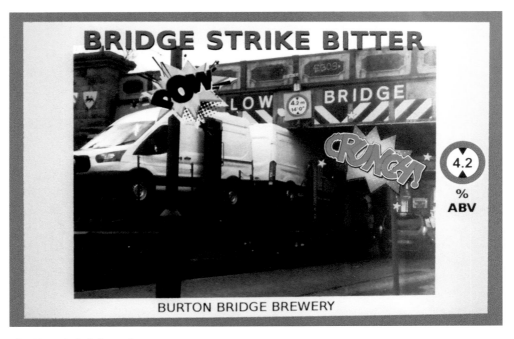

The Bitter-Suite's house beer.

2. Beer and Brothels

The importance of Lichfield as a coaching hub was one of the reasons why the city also became famous for its many taverns and inns. In the eighteenth century, the heyday of the stagecoach, Lichfield boasted eighty such establishments along with numerous beerhouses, which were only allowed to sell ale brewed on the premises. At a time when the population of Lichfield was 3,500 there was, therefore, approximately one pub for every forty-four men, women and children in the city. Two of Lichfield's famous coaching inns still exist as drinking establishments – the King's Head and the George Hotel – both of which are to be found in Bird Street. Others like the Old Crown in Bore Street and the Talbot in Bird Street have since disappeared. The Swan, an imposing building also in Bird Street, first mentioned in 1392, has ceased to be a pub and is now the home of two restaurants. Higher standards of hygiene and the growth of the temperance movement in the years before the First World War led to a decline in the number of pubs in the city. By 1910 the number had fallen to fifty-three and by 1931 the figure had dropped to forty-three. At the time of writing there are about thirty licensed premises in Lichfield including three micropubs.

DID YOU KNOW?
James Boswell, Samuel Johnson's friend and biographer, whose statue stands in Lichfield's market square, was an inveterate user of prostitutes. His journal is littered with examples of how he sought out professional sex workers, especially on the streets of London, and how he contracted sexually transmitted diseases on a number of occasions. Prostitution was a very dangerous business. Each year in the last quarter of the eighteenth century some 5,000 prostitutes died from assorted causes including murder.

Lichfield became famous for the quality of its beer and in medieval times rivalled nearby Burton-on-Trent in its production of ale. In 1705 the playwright George Farquhar, while staying at the George Hotel, described Lichfield beer as being 'as smooth as oil, sweet as milk, clear as amber and strong as brandy'. Samuel Johnson was proud of his hometown's beer and quaffed large amounts of it on his frequent visits to the city. A large brewing industry had grown up in Lichfield by the end of the eighteenth century and by 1834 there were three breweries supplied by nineteen maltsters, most of which were situated in Greenhill, Tamworth Street and Lombard Street. In 1869 Lichfield's

two biggest breweries merged to form the Lichfield Brewery Company and in 1873 a new brewery was built in Upper St John Street. The building can still be seen to this day opposite the Bitter Suite micropub, even though the brewery was eventually bought out by Burton brewers Samuel Allsopp & Sons and had closed down by 1931.

The Duke of York, a popular pub at the top of Greenhill, is one of Lichfield's oldest public houses still in existence, possibly dating from the fourteenth century. However, its name derives from the Duke of York, who eventually went on to become James II in 1685.

The Three Crowns in Breadmarket Street was Dr Johnson's favourite public house. The pub, which was next to the house in which Samuel Johnson was born, was where the great writer chose to stay when he visited Lichfield. In 1776 he showed James Boswell the delights of his hometown and the pair drank a lot of Lichfield ale and sampled Staffordshire oatcakes, both of which Boswell liked a great deal. In the building on the other side of the Three Crowns was the house where another of Lichfield's famous sons, Elias Ashmole, was born. The Three Crowns' long history did not save it from closure in the 1960s. Today a plaque on the wall is the only clue to passers-by as to the building's illustrious past.

Another Lichfield public house with a long history was the Old Crown on Bore Street. One of Lichfield's coaching inns, it dated from the early eighteenth century and was the meeting place of the Lichfield Turnpike Trust, the body in charge of the roads in and around the city. Inquests into the deaths of individuals were frequently held in public houses, often with

The former offices of the Lichfield Brewery.

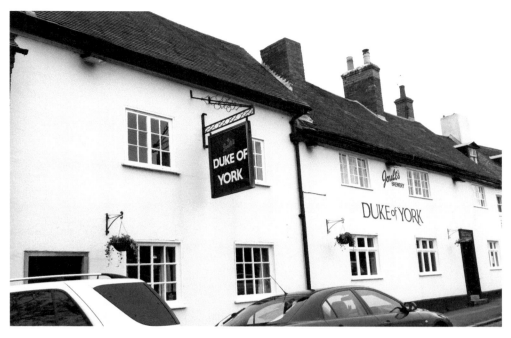

The Duke of York public house.

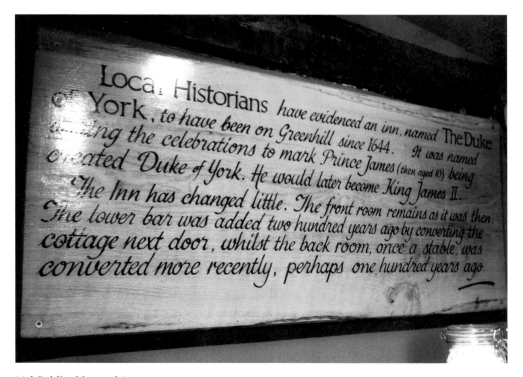

Lichfield's oldest pub?

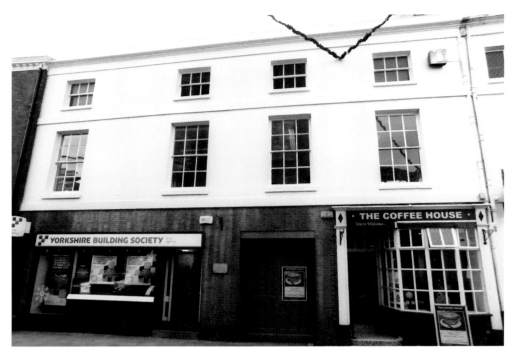

The one-time Three Crowns Inn.

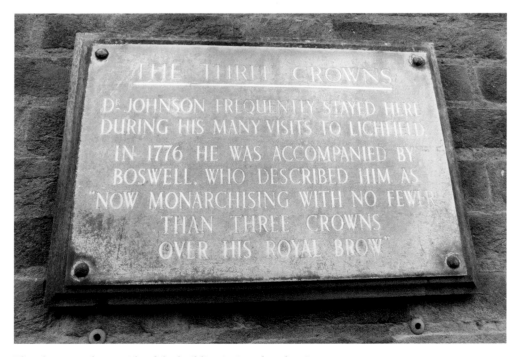

The plaque on the outside of the building in Breadmarket Street.

the deceased person in question being on display in the room. The Old Crown was one of the establishments where such inquests took place well into the twentieth century, when thankfully for hygiene reasons the practice was stopped. Sadly the Old Crown, with its many attractive low-ceilinged rooms and popular folk music nights, closed in 1983 and the ancient building was, somewhat controversially, subsequently demolished.

There has been a pub called The Bowling Green with an actual bowling green adjacent to it for centuries. Bowls have been played on the site since the 1670s and the pub itself was first mentioned in 1737. Situated in the Friary, the present pub was totally rebuilt in 1929 in an attractive mock-Tudor style and stands in the middle of a large and busy traffic roundabout. For a while in the 1980s, for some arcane reason, it was renamed The Monterey Exchange but thankfully reverted to its traditional name in 1994.

A fatal shooting took place at the Gresley Arms public house on 5 November 1878. The landlord, George Green, fired a gun inside his pub 'as a lark' to 'frighten' those customers who were drinking in the pub. Unfortunately the gun, which Green had thought was unloaded, had a marble stuck down its barrel and when the gun was fired the marble struck Samuel Bates, a Walsall man, in the head, killing him instantly. At the inquest, the coroner had suspicions that the next-door neighbour, Henry Styche, who had lent Green the firearm, may have deliberately placed the marble in the gun but as there was no evidence to prove that this was the case, the verdict of the inquest was one of accidental death. The Gresley Arms, which was demolished in 1931, used to stand where the delivery area close to the Argos store is now sited.

Another tragedy occurred at the Bridge Tavern. The pub, situated in Upper St John Street, dated from 1861 and stood opposite the Lichfield Brewery. The landlady at the time was Mrs Ann Gething, who had been left to run the pub and bring up her family after her husband had drowned himself in Stowe Pool. Then in 1883 her son, James, suffering

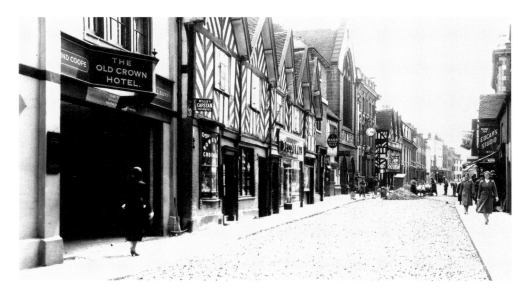

The Old Crown, *c.* 1940.

The Bowling
Green public
house.

The site of the
Gresley Arms.

from depression, hanged himself in a nearby barn that was also owned by the family. Despite these terrible events Mrs Gething continued to run the pub and also manage a coal merchant's business for many years. The Bridge Tavern closed in 1986 but today the building is the home of one of Lichfield's excellent micropubs, The Bitter Suite.

Brothels in Lichfield have also had a long history but thankfully, unlike the city's pubs, they have apparently died out. Like the numerous public houses they were often there to serve the needs of the coaching trade as well as the red-coated soldiers who were billeted in the city. As long ago as 1466 a woman in Conduit Street (then called Butcher Row) earned the large sum (for the time) of £3 by making her home and herself

available to the household of the Duke of Clarence when he made a visit to Lichfield. In the fifteenth century Beacon Street (then called Bacon Street) was the main area for brothels and in 1485 houses of ill repute were also recorded in Wade Street and Greenhill. Quonians Lane, off Dam Street, may also have been a medieval 'red light' area of the city.

Lichfield pubs have rarely been associated with such questionable activities but one that did let down the reputation of the city's inns and taverns was the Anchor public house, which once stood on the corner of Beacon Street and Abnalls Lane. In 1890 the pub's licence was taken over by Henry Cheeseman, who was to cause a scandal that would eventually result in the pub closing down a year later, never to reopen. In February 1891 Cheeseman was brought to court charged with 'keeping his pub as a brothel' after a number of soldiers had been found in bed with 'women of ill repute'. Found guilty,

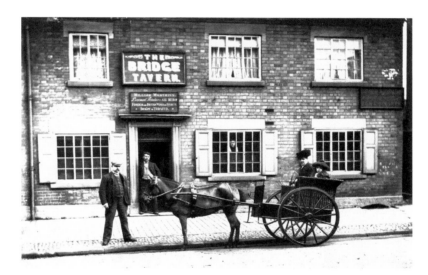

The Bridge Tavern, *c.* 1906.

Quonians Lane.

the landlord was fined £20 with costs or three months in prison. Cheeseman told the court that he could not pay the fine and so was gaoled. Magistrates refused to renew the license of the Anchor and in December 1891 the pub was sold at auction for £165. Some time later the building was demolished and the land sold. Today the site of the Anchor forms part of the gardens of private houses.

In 1943 the local newspaper, the *Lichfield Mercury*, reported on the 'shocking case' of a Lichfield house being used as a brothel. The house, in Wade Street, had been frequented by American soldiers and had been occupied by a thirty-seven year-old widow, two other women aged twenty and twenty-five and six children aged between one and ten. Local police officers, as well as a number of United States military policemen, raided the house and the children were taken into care. The occupants were found guilty of operating a brothel; the older woman was gaoled for three months and the two younger women were fined. The presiding magistrate at their trial gave a warning at the beginning of the trial stating that the case would produce evidence of 'an unpleasant character' and that 'any female who elected to leave the court should do so.' Reportedly no women left the courtroom.

DID YOU KNOW?
The Turk's Head pub in Sandford Street had a name that harked back to the crusades of the Middle Ages. The pub itself only dated back to the early eighteenth century, however, and was one of those inns that served the important coaching route between Lichfield and Liverpool. A popular pub, it nevertheless closed in 1990 and the building was demolished to make way for the Swan link road.

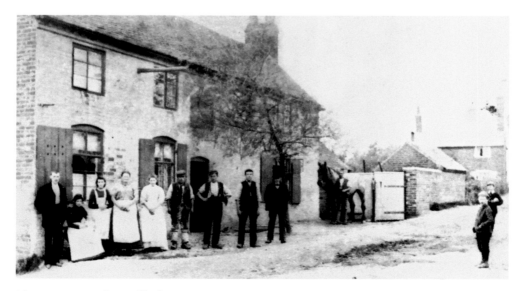

The one-time Anchor public house in Beacon Street.

3. Sickness and Health

In the past when there were few effective medicines and limited medical knowledge the chances of dying at an early age were very high. Lichfield, like most other places, was periodically visited by outbreaks of the plague, known to history as the Black Death. One such outbreak in AD 672 was responsible for the death of St Chad, who had brought Christianity to the Lichfield area. In the fourteenth century the plague killed around a third of the population of the country and Lichfield would not have escaped. Almost as devastating was an outbreak of the disease in the city in the year 1593.

However, the Black Death was not the only fatal illness that was rife in the past. In 1882, for example, there was an outbreak of the deadly disease typhus in the city. It began in a lodging house in George Lane when one of the lodgers became ill and doctors sent him to the workhouse, which had medical facilities where he could be isolated. The lodging house landlady soon followed and Lichfield residents were urged by the authorities to keep their houses well ventilated, ensure their own personal hygiene and avoid crowded areas. At the time many people blamed the state of Lichfield's sewers as the cause of the outbreak.

Smallpox was another disease that at one time was often fatal. In the eighteenth century, however, it became the first infectious disease to be treated by the process of vaccination. William Dyott, from one of Lichfield's long established aristocratic families, was, according to his diary, one of the first in the country to receive the smallpox jab. In spite of this the disease did make periodic visitations to Lichfield. As late as 1902 an outbreak of smallpox occurred at the Lichfield Workhouse and caused panic throughout the city. Seemingly a vagrant admitted to the workhouse's 'tramp ward' had been suffering from the disease and was quickly quarantined. The 'tramp ward' was closed down and all inmates were vaccinated. One such inmate refused to be vaccinated, striking one of the officials and pulling out a knife; as a result he was locked in a room. The Board of Guardians, the body in charge of the workhouse, encouraged the inmates to have the anti-smallpox jab by explaining that recently Edward VII had been vaccinated to set an example to others.

In 1916 the most serious outbreak of measles for fifty years hit the city. The epidemic caused all schools in Lichfield to be closed and those suffering from the disease were isolated to try and stop the airborne infection from spreading. Altogether there were 350 cases of measles in the city with sixteen deaths being attributed to the disease. It was not until the 1960s that an effective vaccination for measles was found and, at least in developed countries, the disease was virtually eliminated.

An influenza epidemic caused 'acute anxiety' in the city in November 1918 just as people were celebrating the end of the First World War. Worries about the spread of the disease led to the closing of schools in the city and in outlying villages. Overcrowded homes and lack of milk were seen as the main causes for the rapid spread of flu. The devastating

Lichfield Workhouse, which is now part of the Samuel Johnson Community Hospital.

outbreak of Spanish Flu in 1918 was a global pandemic that infected 500 million people throughout the world. Around 10 to 20 per cent of those that contracted the disease would go on to die.

DID YOU KNOW?
In 1906 the medical officer of the city issued a report on the health of the people of Lichfield. The report stated that the population of Lichfield was 7,902 and that in 1905 229 births had taken place in the city along with 122 deaths, twenty of which had been at the Union Workhouse. The report concluded that the entire district had been free of all dangerous infectious diseases in the previous year.

It was during the First World War that sixty human skeletons were found buried at Freeford during work to widen the Lichfield to Tamworth road. The skeletons, which were in a good state of preservation, were first thought to belong to soldiers from the Civil War period. However, dating evidence proved that they were the remains of leprosy victims from the Middle Ages, who had claimed sanctuary at the Leper Hospital of St Leonards situated on the site. One of the skeletons had belonged to a person aged just eighteen or nineteen years old.

In the days before the National Health Service and effective medicines there were many quack remedies on sale to the public, and the newspapers of the times were full of 'cure-all' pills and potions. For example, in 1769 the *Birmingham Gazette* carried an advert placed by a Doctor Uytrect, who had taken offices above Mr Follat's watchmaker's shop in Lichfield's Market Street. The advertisement proclaimed the doctor was 'the famous physician and occulist' who had produced some 'remarkable cures' for people who had otherwise been deemed incurable. The advert went on to assert that various people in Lichfield had been helped by the 'remarkable' doctor including Mary Bannister, a child who had been blind and could see again, and twenty-two-year-old Sarah Reeves, whose throat cancer had been 'cured'. Such claims from obvious 'snake oil' salesmen, were, unfortunately, all too common at the time.

Generally speaking the health of those living in Lichfield in the past was reasonably good. This can perhaps be put down to the city, from an early point in time, being lucky enough to have had a good water supply. Water from local springs was piped to a number of conduits around the city including the Crucifix Conduit, which faced the end of Bore Street and which, from the mid-nineteenth century, was marked by the clock tower that was later moved to the Friary. Another conduit stood in Conduit Street (previously known as Butcher Row) and another stood at the junction of Tamworth Street and Lombard Street. Cathedral Close had its own water supply from the twelfth century and its own conduit from 1803, which was in use until 1969.

Conduit Street.

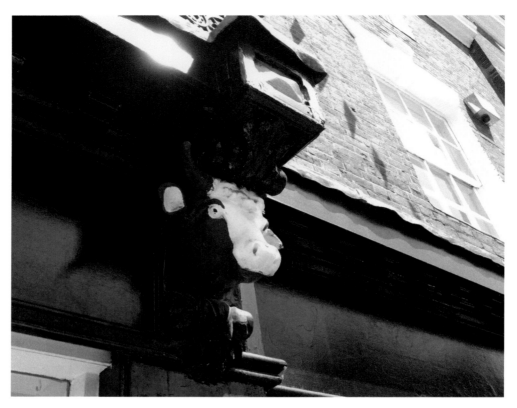

A bull's head in Conduit Street, which was once known as Butcher Row.

In the days when most buildings were timber framed, fire and its prevention were often uppermost in people's minds. Most houses had leather buckets to hand and also long poles with hooks on the end in order, if necessary, to pull down any burning thatch. In Lichfield, in the eighteenth century, a hand-operated fire engine was kept at the ready beneath the spire of St Mary's Church. Anyone who wanted it could drag it to the scene of a fire and were charged for the privilege of using it. Watchmen at one time were employed to patrol the streets at night often waking up householders so they could sniff for smoke.

DID YOU KNOW?
In 1948 Lichfield's Lido cinema showed a film entitled *Birth of a Baby*, which was described as 'the most discussed film of today'. The film had been shown throughout the country and had been responsible for some grown men fainting or having to leave the cinema early because they were feeling 'queasy'. Lichfield Magistrates agreed that the film, which the local press described as 'delicately produced', could only be shown to those over eighteen years old.

4. Crime and Punishment

Mounted highwaymen were not the only type of criminals to plague the surrounding area in the eighteenth century: footpads also operated in and around the city. Swinfen, just to the south of the city, was a common place for highway robbery. In October 1767, for example, a gentleman on horseback was stopped on the road by a man on foot and had his expensive silver watch taken by the robber, who was 'wearing a short coat of a drab colour and a flapped hat'. A reward of £5 was offered for the return of the watch and the conviction of the felon.

The fact that Lichfield was a garrison town with many soldiers in the city sometimes led to problems. In November 1771, for instance, a party of six troopers from Lord Albemarle's Regiment, the 3rd Regiment of Dragoons, delivered four deserters to the city and handed them over to the military authorities. The troopers then spent some time in a Lichfield beerhouse after which an argument broke out between them that resulted in one pulling out his pistol and shooting dead another of his colleagues. The murderer was apprehended and sent to Stafford gaol to await trial.

Horse stealing was a fairly common crime in the area and was frequent enough to prompt a number of concerned residents in August 1769 to create a fund that could be used to track down horse thieves. Some of those subscribing to the fund were prominent Lichfield citizens such as Erasmus Darwin and Thomas Seward of the Bishop's Palace.

In the past horse stealing, along with over 200 other offences, was one of the crimes that would earn the culprit a death sentence. Executions in Lichfield were a relatively rare occurrence but they did take place, usually on gallows set up outside the city on the London Road/Tamworth Road crossroads, where the Shell service station now stands. Lichfield's first recorded execution took place in 1175 when a number of men were hanged for the murder of a royal forester. Much later another individual hanged was John Jones in August 1735. He had been convicted of stealing a horse and 35s from John Sudbury as well as assaulting him. In 1711 the Sheriff of Lichfield was instructed to carry out two executions: one was a man condemned for murder and the other a woman who was sentenced to death for stealing a pair of shoes, a straw hat with brimming, a loaf of bread and some cheese. In October 1762 the corpse of a hanged man was taken to the house of the famous Lichfield doctor Erasmus Darwin, who then began a series of anatomical lectures during which the criminal's body was dissected. The lectures, advertised in local newspapers, took place in front of an audience of 'any who profess medicine and surgery' each Tuesday evening for 'as long as the body can be preserved'. (An Act of Parliament in 1752 had made the dissection of hanged felons legal.)

DID YOU KNOW?
In June 1856 special trains ran from Lichfield to take local people to the county town of Stafford to witness the public hanging of the notorious murderer William Palmer. The Rugeley Poisoner, as Palmer was known, was a local doctor who had been convicted of poisoning his friend and gambling companion John Parsons Cook in a trial that had caused a sensation throughout the country. 30,000 people were able to witness Palmer, with a smile on his face, go to his death.

The last public hangings in Lichfield took place in June 1810 when three men – twenty-five-year-old John Neve, twenty-six-year-old Walter Weightman and James Jackson, who was thirty-nine – were executed for forgery and the passing of counterfeit money and cheques. Hundreds of local people watched the execution and witnessed the men hanging for one hour (in order to ensure death had occurred) before relatives quickly took them down, afraid that they too would end up being dissected by local anatomy students. All three were buried together in St Michael's churchyard with a simple stone marking the spot. As can be seen from the photograph at some point in the past someone, perhaps a relative of one of the men, has chipped out the words 'hanged at' from the stone.

Other non-capital crimes were also dealt with very harshly. Lichfield felons often found themselves put in the pillory, which was set up in a prominent place in the market square, about where the statue of Dr Johnson is now situated. For example, in October 1735 William Boyde, found guilty of stealing a watch, was sentenced to be stripped and then whipped down Bore Street, Conduit Street, Market Street and Bird Street before being put in the pillory. In March 1750 Jane Greer was found guilty of stealing a neck of mutton and was sentenced to be 'whipt at the pillory tomorrow at twelve of the clock' and in 1752 Abraham Messire was found guilty of stealing 'a forequarter of mutton' and sentenced to be 'publickly whipt' at the time of the next market. While in the pillory the wrongdoer, often depending on the seriousness of the crime, could expect to be pelted with rotten fruit as well as dead cats and excrement. In extreme cases, however, the throwing of rocks by unruly or drunken mobs or by revenge seekers would result in the criminal literally being stoned to death.

Perhaps the most horrifying episodes in the whole history of Lichfield were the burning alive of individuals for their beliefs. In December 1557 Joyce Lewis from Atherstone was burned at the stake in Lichfield's market square for heresy. She was a Protestant married to a Catholic and her husband insisted that she should worship at his church. In protest she turned her back on the altar, a dangerous thing to do in the reign of the Catholic queen 'Bloody' Mary Tudor. The Bishop of Lichfield ordered her arrest and she was tried in Lichfield and sentenced to death. Just before she was taken to the stake and her horrible demise she was comforted by two local ladies, Margaret Biddulph and Joan Lowe, who gave her some wine to drink. Also burned to death in Lichfield for their Protestant beliefs during the reign of Queen Mary were Thomas Hayward and John Goreway, both executed in the market place in September 1555.

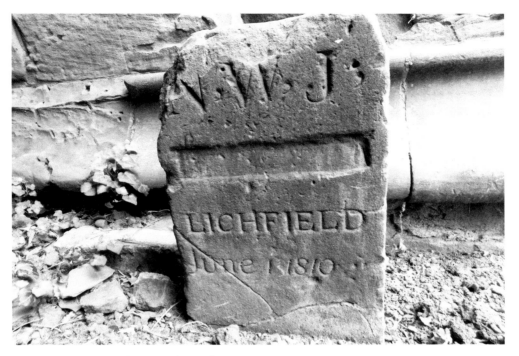

The gravestone of the three men hanged in 1810.

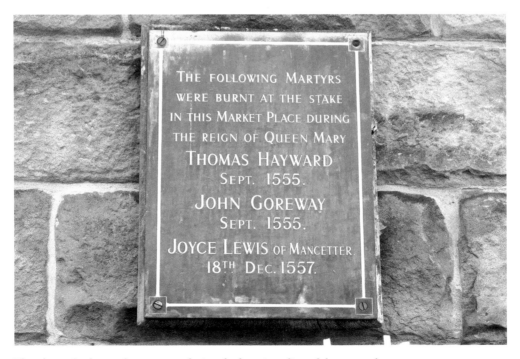

The plaque in the market square relating the burning alive of three people.

Another man, Edmund Gennings, also met a grisly fate due to his religion. Born in Lichfield in 1567 he was ordained as a Catholic priest in 1590 and was arrested while performing an illegal mass in London. He was found guilty of heresy and treason and was condemned to be hanged, drawn and quartered, with the sentence being carried out in London on 10 December 1591. On the scaffold the condemned man was asked by a priest to 'confess his treason', but Gennings responded 'if to say Mass be treason, I confess to have done it and glory in it'. Soon after, while being disemboweled, Gennings spoke aloud a prayer and the executioner was amazed that his victim continued to say the prayer even as he cut out the poor man's still-beating heart and held it in his hand.

Another victim of the death sentence for heresy was Edward Wightman. In April 1612 he became the last person in Britain to be burned at the stake for the crime. Wightman, from Burton-on-Trent, was an extreme Puritan who publicly rejected much of the church's teaching and proclaimed himself to be a mouthpiece of God and the Messiah promised in the Old Testament. Found guilty of heresy he was taken to the market place, chained to the stake and large faggots of wood were piled about him up to his waist. The fire was lit and as it began to scorch him he yelled out that he would recant his blasphemies. Some bystanders quickly dragged the burning wood away from him and unchained him from the stake. Three weeks later he was taken to the courtroom to formally recant his views but he refused and according to the official record 'blasphemed more audaciously than

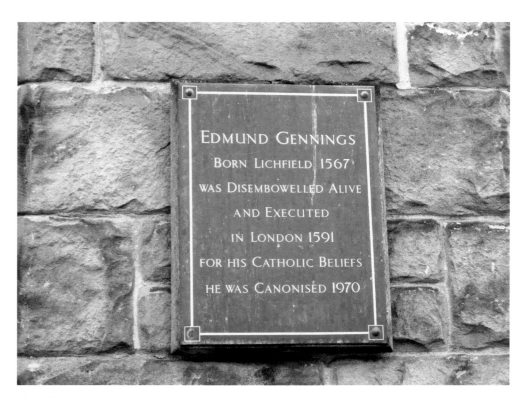

The Edmund Gennings plaque.

before'. Consequently on 11 April 1612 he was chained to the stake again and this time there was to be no reprieve. It was said by an observer of the dreadful execution that Wightman 'died blaspheming'. Today another plaque in Lichfield's market square marks the spot where Wightman met his cruel fate.

The present Guildhall in Bore Street was rebuilt in 1846. Before then it had served not only as the meeting place for the Lichfield Corporation, the body that governed the city, but also as the city prison and 'house of correction'. In the basement of the building there were eleven rooms and cells, dating from around 1545, including two rooms for debtors and a condemned cell. A high castellated wall separated the prison from Wade Street. Today the cells are on display to the public and are well worth a visit.

We are lucky today to live in a peaceful place like Lichfield but it was not always the situation. In June 1902, for example, the city experienced riotous behaviour seldom witnessed before. The *Lichfield Mercury* newspaper reported that a large crowd of people 'some hundreds strong' had gathered at the top of Greenhill in an area known as The Gullet, close to The Duke of York public house, where they were watching two men fighting. When the police arrived to break the fight up the crowd became 'rather obstinate' and the police officers were 'badly treated' by the crowd. When the police attempted to arrest one man a number of constables were 'knocked about'. Eventually order was restored and six people were arrested, including one woman, and charged with

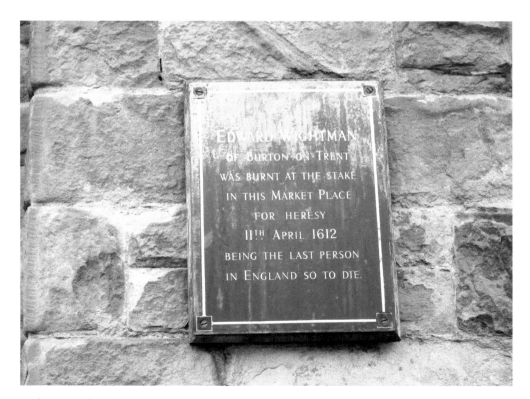

A plaque marking the death of Britain's last heretic.

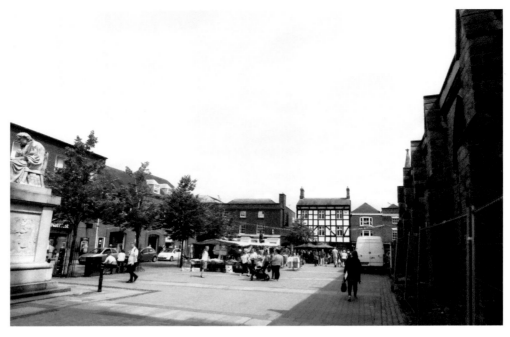

Where it all happened: Lichfield's market square.

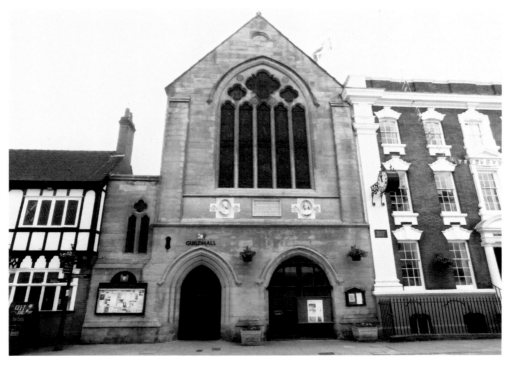

The Guildhall.

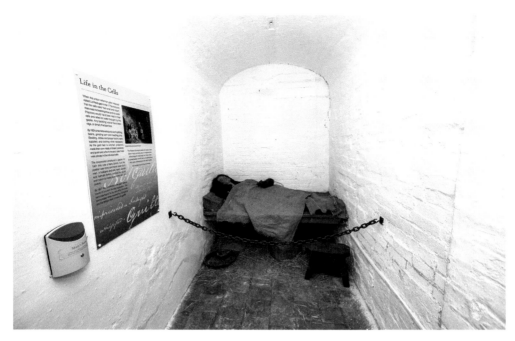

The Guildhall cells.

being drunk and disorderly. Found guilty, the six were given prison sentences with hard labour. The Greenhill, with its many pubs and tightly packed slum housing, was often the scene of similar disturbances in Victorian and Edwardian times.

DID YOU KNOW?
In August 1881 a shocking case of vandalism took place in St Michael's churchyard when marble crosses and stone monuments were pulled down and broken. The local *Lichfield Mercury* suggested that the perpetrators of the crime were 'young men of a certain class' and when arrested they should be 'flogged naked through every churchyard in England'.

5. Buildings – Religious and Otherwise

Lichfield Cathedral is the only three-spired cathedral in England. The present Gothic building was begun in 1195 and replaced the original wooden Saxon church and the Norman building. The cathedral is dedicated to St Chad who brought Christianity to this area of Mercia in the seventh century and the shrine of the saint was a popular place for pilgrims in the Middle Ages who believed that the touching of it could cure their illnesses. The bones of St Chad were kept in a portable shrine that would be processed around the building and the saint's preserved head would be shown to the pilgrims. One of the great treasures of the cathedral is the Lichfield Gospels, which is written in Latin and dates from around the year 730. The cathedral was badly damaged in the English Civil War of the 1640s with the central spire demolished and the stained-glass windows all smashed. Reconstruction of the cathedral took many years. In 2003 a wooden carving of the angel Gabriel was found under the nave and after testing it was found that it dated from around the same time the Lichfield Gospels were written. Today the Lichfield Gospels and the Lichfield Angel are on display in the cathedral.

In Cathedral Close, opposite the north side of the cathedral, stands the Bishop's Palace. The present building was completed in 1687 and replaced the previous palace built by Bishop Langton in 1314. For many years the Bishops of Lichfield declined to live in the palace, preferring instead to reside in Eccleshall Castle and the building was leased to other church luminaries, notably the Revd Thomas Seward and his family from 1754. It was not until George Augustus Selwyn became Bishop of Lichfield in the nineteenth century that the palace again became the bishop's permanent residence. Today the grand building is the home of the Lichfield Cathedral School.

Bishop Selwyn was by any standards an extraordinary individual. Born in 1809, he became the first Bishop of New Zealand in 1841. On the long sea journey to the country Bishop Selwyn learned the Maori language and when he arrived in New Zealand the Maori people were amazed when the churchman was able to preach to them in their own language. Selwyn travelled all over his new and huge diocese, often on foot and using a pedometer to measure the distance he covered. He made a huge impression on the country and is still held in high regard in New Zealand today. In 1868 he was made Bishop of Lichfield and became well-known in the city and further afield for being highly approachable at a time when high-ranking clerics tended to remain very aloof from their congregations. He could often be seen jumping down from his carriage to help an elderly woman carry her heavy baggage and was renowned in the Black Country for holding services for the barge workers, even converting a narrow boat into a 'floating mission'. Bishop Selwyn died in 1878 and was buried in the cathedral where an impressive monument to him can be found, which includes some scenes from his life illustrated in beautifully coloured tiles.

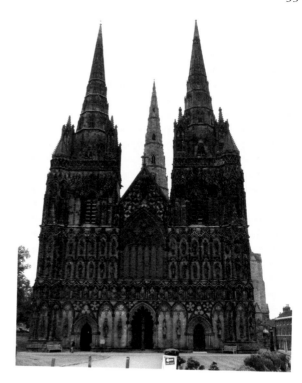

Right: Lichfield Cathedral.

Below: The Bishop's Palace.

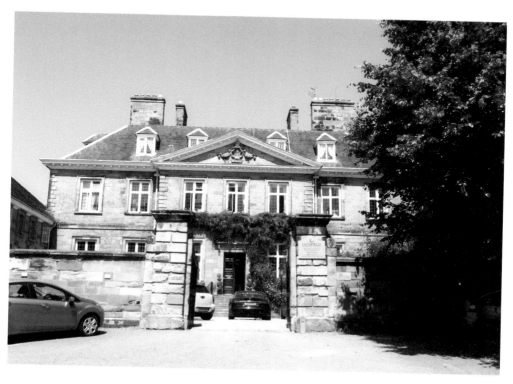

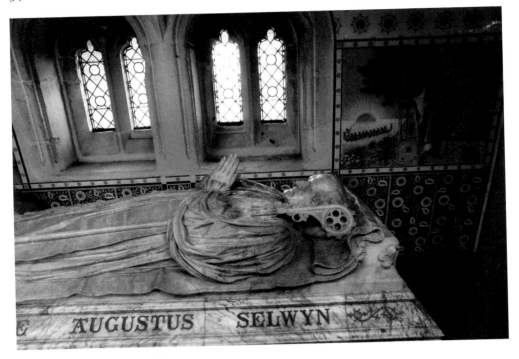

The George Selwyn memorial.

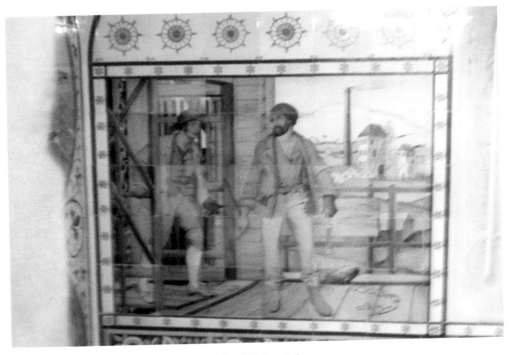

One of the tiles illustrating events in the life of Bishop Selwyn.

Close to the cathedral is Selwyn House, the so-called 'Spite House'. For many years it was believed that the building was constructed by one of the three Aston sisters who had fallen out with her other two siblings who lived in Stowe House and Stowe Hill on the other side of Stowe Pool. According to the story she had built the house in order to spoil the fine view of the cathedral her two sisters had hitherto had from their own residences. Unfortunately the 'Spite House' story is a Lichfield myth as the building had actually been commissioned by the Revd James Falconer in 1780 and was never owned by a member of the Aston family.

DID YOU KNOW?

The cathedral's Shrine of St Chad was destroyed during Henry VIII's Reformation in 1538. The bones of the saint, which were kept in the shrine, were rescued and apparently eventually turned up at Birmingham's Catholic Cathedral in the nineteenth century. In 1995 the bones were examined and carbon-dated, and it was discovered that they did date from the time of Chad but that the bones actually belonged to two people.

The so-called 'Spite House'.

A Franciscan friary stood in Lichfield from the year 1247 and consisted of a large church, cloister, dormitory and refectory. The Franciscans were well known for looking after the poor and sick in the area. In 1538 on the orders of Henry VIII all monasteries were dissolved and the Lichfield Friary was demolished with the land being sold off in order to swell Henry's coffers. Today the site of the friary is a protected ancient monument and public garden with the outline of the original buildings clearly marked in paving slabs, which were laid after the site was excavated. A classical portico was erected as an entrance to the garden in 1937. The structure appropriately came from Shenstone Court, the home of Sir Richard Cooper, the man that had given the friary area to the city in the 1920s.

Milley's Hospital, an almshouse, was first endowed in 1504 by Thomas Milley, a canon of the cathedral. He provided the funds to enable fifteen poor women to live in the building and receive an income of 5s each quarter. In 1987 the building was modernised to include ten flats and the addition of a common room. The establishment still functions today in its traditional role and the red-brick two-storey building retains many of its original sixteenth-century features. A plaque over the entrance door commemorates the work of Thomas Milley.

Stowe Street, once the home of several well-loved public houses, all of which have now disappeared, is the home of one of Lichfield's oldest domestic buildings. The Cruck House, dating from the fifteenth century, is a fine example of early timber construction

The Friary Gardens.

Milley's Hospital.

and was one of the few original buildings saved when the street was redeveloped and pedestrianised in the 1960s. Today the Cruck House is used as a meeting hall for the local community.

Redcourt House was the home of Samuel Johnson's stepdaughter Lucy Porter. Built in 1766 at a cost of £3,000, it was situated at the top of Tamworth Street. The house, which by all accounts was an imposing and attractive building, was demolished in 1929. In 1959 a building housing Lichfield's GP's surgery, which was also called Redcourt House, was built on the site but that in turn was demolished in 1980 when Greenhill Health Centre was opened. Today the area where Lucy Porter's grand home once stood is a busy car park.

The impressive Corn Exchange in Conduit Street was built in 1849 following the repeal of the controversial Corn Laws and enabled local farmers to sell their grain in one place and compete with the new cereal imports from North America. It included an octagonal-shaped hall with a balcony and arches on the ground floor where market stalls were situated. Today the building is a restaurant and the arches have been converted to shops.

The second public library in the whole of the country was built in Lichfield. Completed in 1859, the building, which at one time also housed a museum, stands at the end of Bird Street, near to the entrance to the city's Museum Gardens and today is used as Lichfield's Registration Office. On the side of the attractive building is the statue of a sailor with the name of HMS *Powerful* on his naval cap. The *Powerful*, one of the largest warships in the

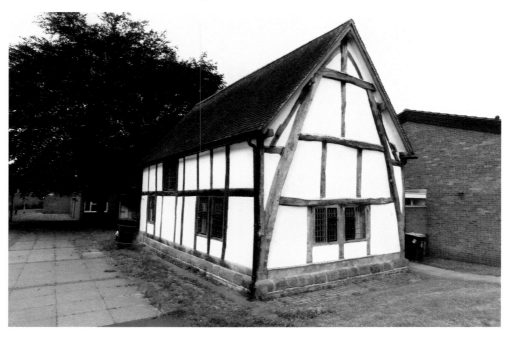

The Cruck House.

Redcourt car park.

The Corn Exchange.

Royal Navy at the time, was built at the Vickers Yard in Barrow-in-Furness and launched in 1895. Captained by Hedworth Lambton, the ship played a significant part in the Boer War in South Africa when the naval brigade from the ship attacked Boer positions in the town of Ladysmith in November 1899. So important was that particular action that the men of the ship were feted back in Britain as 'the heroes of Ladysmith'. During the First World War HMS *Powerful* and her sister ship HMS *Terrible* served as troop transports. In 1919 it was converted into a training ship and was eventually broken up in 1929. The statue of one of the *Powerful's* naval brigade was presented to the city by its sculptor, Robert Bridgemen, after it had been rejected as part of a Boer War memorial in York.

The clock tower, which today is situated in the Friary, close to the Bowling Green public house, originally stood at the end of Bore Street. Built in 1863, it was moved to its present position in 1926 when Friary Road was constructed. In 1984 the clock tower faced a crisis and it seemed likely that it would have to be demolished due to damage caused by deathwatch beetles and vandals. However, the city council decided that the tower with its 'strong historical connections' ought to be saved and stumped up £30,000 to preserve it.

Older Lichfield residents will well remember the noisy cattle market, which was situated where the Tesco supermarket now stands. In bygone days livestock would be herded along roads into the city and occasionally animals would stray. This led to the building of a number of walled pinfolds around the city where stray animals, having been

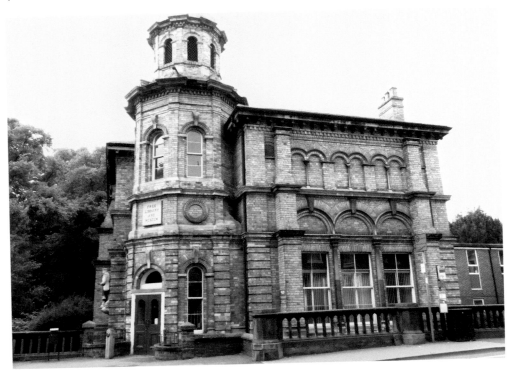

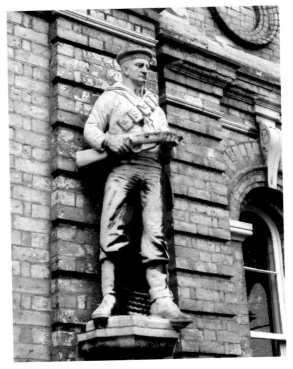

Above: The original public library.

Left: The unusual statue on the old library building.

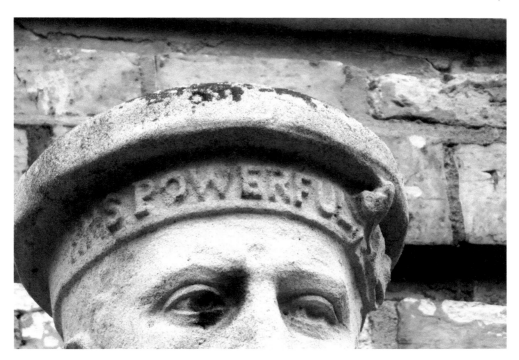

The statue's cap detail.

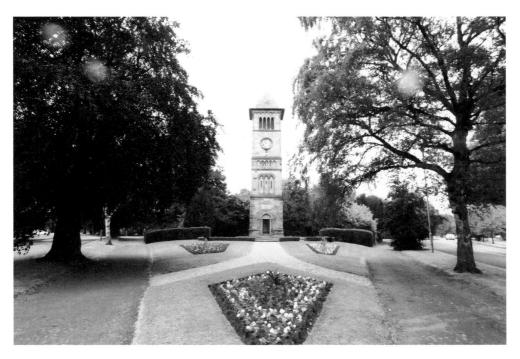

The clock tower.

rounded up, could be kept until their owners could claim them. One of these Lichfield pinfolds has been beautifully preserved and can be found on Beacon Street on the corner of the appropriately named Pinfold Road.

In 1891 Lichfield's medical officer condemned the houses in Cotton Shop Yard, off Lombard Street, as not fit for human habitation and the buildings were demolished. The road name disappeared and today modern housing and a private car park have replaced the slum buildings. There were other places in nineteenth-century Lichfield, particularly around the Greenhill area, where houses were small, overcrowded and unhealthy. Social reformer Sophia Lonsdale reported that the slums in Lichfield at the time were worse than anything she had ever seen in London.

Lichfield's first workhouse was situated in Stowe Street and at the time was called the 'Stowe House of Industry'. In 1840 a new and larger workhouse opened on land opposite St Michael's Church after the three parishes of the city pooled their collective poor-relief resources. Inmates at the Lichfield Union Workhouse were subjected to a demanding regime, rising at 5.45 in the morning. Dressed in grey uniforms they would work from 7 a.m. until noon when they were given a break for one hour and then expected to work again from 1 p.m. until 6 p.m. Bedtime was at 8 p.m. Work for men was usually picking oakum and stone breaking while the women were employed in sewing and cleaning. Workhouse food was generally created from cheap ingredients to keep down costs.

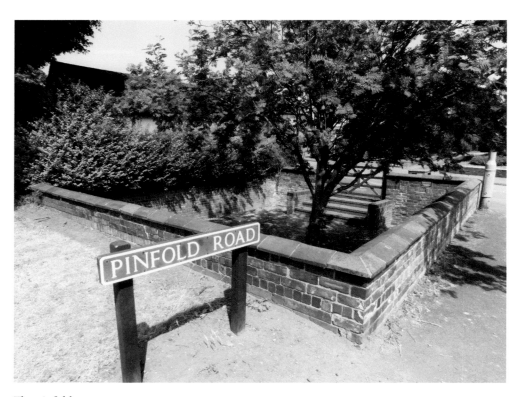

The pinfold...

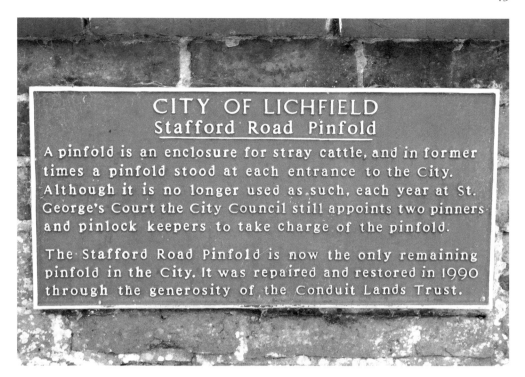

...and nearby sign.

Breakfast and supper consisted of gruel (a watery porridge) and lunch usually consisted of cheap cuts of meat along with potatoes. Washing and toilet facilities for both sexes were extremely basic. In 1948 the workhouse officially became St Michael's Hospital and today the building forms part of the Samuel Johnson Community Hospital.

DID YOU KNOW?
St Michael's Church, part of which dates from the thirteenth century, was where Samuel Johnson's parents, Michael and Sarah, as well as his brother, Nathaniel, were buried. An extensive churchyard surrounds the imposing church, which sits atop a high ridge and which may have been the site of an ancient burial ground long before Christianity came to Britain.

Around Lichfield the visitor will notice the many plaques and signposts informing visitors of various historic events and where those famous sons and daughters of the city were born or once resided. It is indicative of local humour, however, that one plaque in Dam Street informs people of, well, very little!

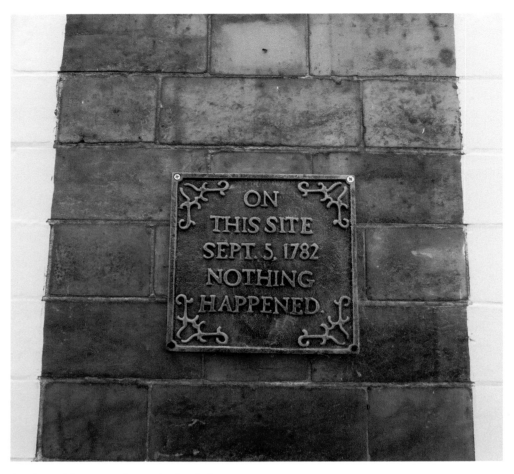

Another of the many plaques in the city!

6. Byways and Tunnels

In the days of the stagecoach roads throughout Britain were extremely variable in terms of their quality and upkeep. In Lichfield, and in the area around the city, the standard of roads was a good deal better than in most other places due to the fact that they had been 'turnpiked' at a relatively early stage. Toll gates were set up around the city and the tolls, collected from travellers in and out of the city by the Lichfield Turnpike Trust, were used to maintain the roads. The toll gates numbered seven in all by 1781, including one in Beacon Street, just to the north of Gaia Lane, where the toll house stood next to the George & Dragon public house and where coaches and wagons sometimes unloaded their passengers to avoid paying a toll on entering the city. Another toll gate stood beside St John's Hospital, an almshouse in St John Street, and a further one was placed at the bottom of Tamworth Street. To go through the toll gate each coach had to pay 6*d* (2.5p), and the owner of each horse or mule 1*d* and for each twenty head of cattle 5*d*.

A number of roads in Lichfield have long and interesting histories. Bakers Lane disappeared when the shopping precinct was built in the mid-1960s but the precinct still

Originally a toll house in Beacon Street.

follows its original line. It was known as Baxter Lane in the thirteenth century (a baxter being an ancient name for a butcher) but by 1698 it was called, interestingly, Peasporridge Lane. A number of other city streets have changed their names over the years. Market Street was originally called Sadler Street; Bore Street was formerly known as Borde or Board Street, named after the stalls, or boards, which would have been set up to sell produce; and Conduit Street was at one time called Butcher Row and before that was known as Wolechepying.

Quonians Lane, off Dam Street, is today one of Lichfield's most charming little streets. However, when Samuel Johnson was a small boy he was so short-sighted he had to have someone escort him to his first school, run by Anne Oliver (on the corner of Dam Street and Quonians Lane) so that he wouldn't fall into one of the open sewers or soughs that drained across Dam Street, down into Quonians Lane and eventually into Stowe Pool. For many years Quonians Lane was the home of R. Bridgeman & Sons, a long established firm of wood and stone carvers that specialised in restoration work at the cathedral and churches in Lichfield and throughout the whole country.

Breadmarket Street, the small thoroughfare on which is situated the house where Samuel Johnson was born, lies adjacent to Lichfield's market place and at one time was known as Wommones Chepyng and was designated as an area of the market reserved for female sellers. The street was also where the antiquarian Elias Ashmole, the founder of Oxford's Ashmolean Museum, was born in 1617, just two doors away from what was to become Dr Johnson's birthplace.

Quonians Lane.

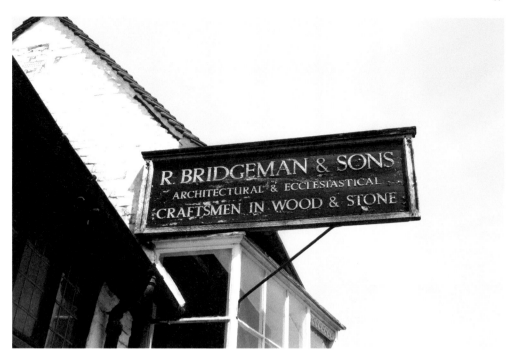

Bridgeman's sign still hangs in Quonians Lane.

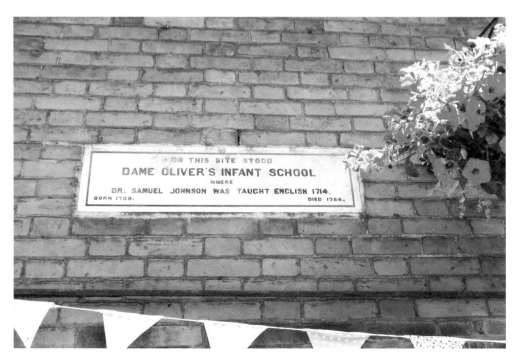

The site of Dame Oliver's school.

DID YOU KNOW?
The twelfth-century Bishop of Lichfield, Roger de Clinton, rebuilt the cathedral, fortified the close and created the town on the south side of Minster Pool. The grid-like pattern of the roads in Clinton's new town was much the same as exist in the city centre today. Clinton also had a ditch built that surrounded the town and at every point where the roads crossed the ditch great gates were built to regulate the traffic entering the city.

Cherry Orchard was, in the late eighteenth century, an actual cherry orchard farmed by the Bramall family. By 1781 the name was given to a cul-de-sac that ran from Sturgeons Hill. The present road was created in the 1950s when it was decided to grace it with the Cherry Orchard name. Frenchman's Walk is named after the French Napoleonic prisoner of war who lived for a time in Frenchman's Cottage in Cherry Orchard. The French officer was called the Conte de Giborne and he spent some of his time giving French lessons to Lichfield children.

Baskeyfield Close, in the Boley Park area of the city, commemorates the bravery of Sergeant John Baskeyfield of the South Staffordshire Regiment who was awarded the Victoria Cross in 1944. He had commanded an anti-tank gun at the Battle of Nijmegen and despite being injured and with all his men out of action he continued to fire the gun. When his own gun was disabled he crawled over to another one and carried on fighting until he was killed. His body was never recovered – he was just twenty-one years old when he died. Today John Baskeyfield's VC is on display at the Staffordshire Regimental Museum in Whittington.

Nearby Coltman Close was named after Lance Corporal William Coltman of the North Staffordshire Regiment. A stretcher-bearer during the First World War, in 1917 he went out three times during a fierce battle in order to rescue wounded soldiers. Awarded the Victoria Cross, he survived the war and eventually passed away in 1977.

Simpson Road is named after Charles Simpson (1800–90), a former Lichfield town clerk who was something of a legend in his time. He had succeeded both his grandfather and father to the job in 1825 and would stay in the role for many years. When he was eighty the Corporation of Lichfield asked him to retire and when he refused they sacked him. As he reluctantly left his office he took with him the city seal, which made it impossible for the Corporation to carry out any official business until a new one had been made.

In medieval times the only way to get to the cathedral from the city was by ferry across the swampy waters where Minster Pool now lies. This was the method used by the many pilgrims travelling to worship at the cathedral's shrine of St Chad. In 1310, however, Bishop of Lichfield Walter de Langton built a 7-feet-wide causeway at the eastern end of Minster Pool, which could carry pilgrims and packhorses across to the cathedral. The causeway served until 1768 when Beacon Street was widened to allow stagecoaches to enter and leave the city and Bishop Langton's causeway was built over.

Perhaps the most mysterious road name in Lichfield is Gaia Lane. No one knows why the road is named after a pagan earth goddess but it may have something to do with the theory that in pre-Christian times the area around the cathedral and St Chad's Church

was once a place of pagan worship. The road is thought by certain people to follow a so-called ley line, the path of an ancient track which some believe has a mystical link and alignment with certain geographical features in the land. However, what is certain is that in the days of stagecoach traffic, and before the widening of Beacon Street in the eighteenth century, Gaia Lane was part of the main coaching route to the north, a concept that is difficult to believe when one notes the narrowness of the road today.

Over the years there have been many rumours that tell of a warren of tunnels beneath the city of Lichfield. One such tunnel, beneath Dam Street, is said to run from the cathedral to the Guildhall in Bore Street. In a book written by Charles Stringer, published in 1819, this tunnel is described as a large subterranean passage of stones several feet below the surface.

DID YOU KNOW?
In July 2009 a metal detectorist, Terry Herbert, discovered the Staffordshire Hoard on farmland near a road into Lichfield. The hoard comprised over 700 gold and silver items dating from the Anglo-Saxon period, some of which were items of great beauty and craftsmanship. Most of the items in the hoard are connected to warfare such as the fittings from the hilts of swords and bits of helmets, although there were also a number of crosses. Why the objects were buried in the first place is a mystery.

Pamela Binns, who lived in the Bishop's Palace in the 1940s, has written that she believed that one of the oldest parts of the palace was a flight of stone steps leading to the garden. In 1940 a large hole appeared at the foot of the steps and as a child she was kept well away from the gaping hole that was said at the time to be the entrance to a secret tunnel leading from Cathedral Close and through which supplies could be delivered during the Siege of 1643. It is possible that during the Civil War sieges of the 1640s such tunnels were dug as escape routes and it is a fact that miners from Cannock were employed to undermine the walls of the cathedral by tunneling in order to facilitate attacks on the close. Other tunnels are said to run from various locations including the Tudor Café in Bore Street, St Mary's House in the Close, between the cathedral and Gaia Lane, and from beneath a building at the top of Greenhill that at one time was the Spread Eagle public house and is now a locksmith's shop.

Another tunnel entrance could be seen in the cellar of what at one time was a pet shop in Sandford Street. The walled up tunnel was believed at on one time to lead to the vaults of Lichfield Cathedral. A local legend tells of a young girl who had been exploring the tunnel before lying down and falling asleep. Perhaps inevitably the story goes that while she was asleep the entrance to the tunnel was bricked up entombing her there forever.

However, the two best-documented examples of the existence of underground tunnels can be found in Beacon Street and St John Street. The Coach & Horses in Beacon Street was one of Lichfield's famous ancient coaching inns and its connection with highwaymen

Gaia Lane.

The Spread Eagle pub.

is detailed elsewhere in this book. The inn closed in the 1840s and the building became a private residence called Whitehall. J. W. Jackson, a former city librarian and historian in the 1930s, wrote how a tunnel ran from the building's cellar all the way to St Chad's Church in Stowe. One theory is that the tunnel was dug during one of the periodic outbreaks of the plague in Lichfield and would therefore allow the owner of the building to come and go and avoid any plague carriers in the vicinity of Beacon Street. However, another theory is that an owner of the inn in the 1840s blocked up the tunnel in order to avoid the plague spreading to the house. Of course, highwaymen interested in making a hurried escape form the authorities could also have used the tunnel in the inn's cellar.

In the cellar of another pub, the Bridge Tavern in St John Street, a tunnel entrance running towards the centre of the city was found by workmen during renovation work in the 1970s. Today the bricked-up tunnel lies below the Bitter-Suite micropub, which now occupies part of the old Bridge Tavern building.

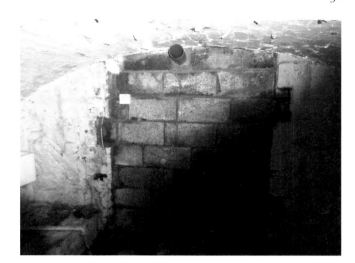

A mysterious tunnel entrance beneath the Bitter-Suite micropub.

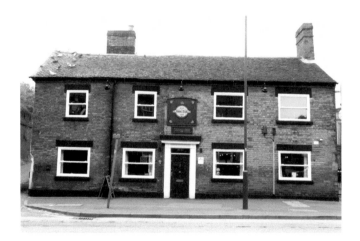

The Bitter-Suite, which was once the Bridge Tavern.

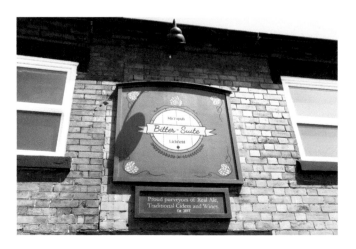

The Bitter-Suite's sign.

7. Fun and Games

Lichfield's annual Bower Day celebration, held in May, originated in medieval times as an assessment of local manpower and military resources when men would have to turn out, armed and armoured, for inspection by the city's authorities. By the eighteenth century, however, the event had become purely ceremonial. The name of the celebration comes from the bower that was erected at the top of Greenhill where the public would be treated to beef, prunes and cake as well as large amounts of local ale. The Greenhill Bower then, as today, also involved a procession of marching bands, tableaux and local dignitaries through the streets of Lichfield, as well as much merriment and drinking in the public houses of the city.

Lichfield races, which began in 1702, was one of the oldest horse racing meetings in Britain. Two race weeks were held each year at Whittington Heath – steeplechasing in the spring and flat racing in the autumn – and they became an important part of the city's social calendar. Concerts, balls and special dinners were held during the race weeks, which attracted visitors from all over the Midlands. The most memorable year in the history of Lichfield races was 1769 when one of the greatest racehorses of all time, Eclipse, won the King's Plate, a race worth 100 guineas, a small fortune at the time. Eclipse would

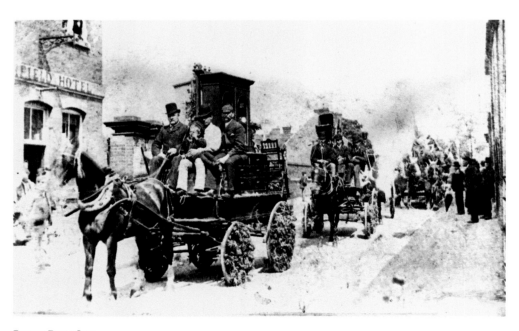

Bower Day, 1897.

go on to win eighteen consecutive races before being retired and put out to stud in 1771. The importance of Lichfield races declined gradually in the nineteenth century and the last meeting took place in 1895 when Whittington barracks was built on the site of the racecourse. However, the original racecourse grandstand still stands today as part of the clubhouse of Whittington Golf Club.

Bull-baiting was a popular 'sport' in Lichfield in the eighteenth century and took place in the market square and on Greenhill. People would bet on whether bulldogs, which had been specially bred for the task, would be able to 'pin' the unfortunate animal by getting a secure grip on a chained up bull's lip or nose. Many of the inhabitants of Greenhill, George Lane and Stowe Street kept bulldogs to take part in the occasion. Bear-baiting also took place in the city until 1835 when an Act of Parliament banned such blood sports. Betting was also conducted on cockfighting, which went on at various locations in the city, especially during Lichfield race weeks. Raising 'mains' of fighting cocks was, by all accounts, a skilled business with the intake of food being particularly important. Some owners fed their birds on custard and eggs while others preferred to feed them wheat, oatmeal, butter and hot wine. A number of public houses, such as the Swan in Bird Street and the Blue Boar in Church Street, had special 'cockpits' where the activity was staged until it too was made illegal in 1835.

One of the first mentions of football being played in Lichfield is in a report in the *Birmingham Gazette* of April 1771. The news story, which illustrates that sports injuries are not just a modern occurrence, relates how some young men were playing football in the city when 'two of them met together and kicked, by which means one had his leg broke'.

The old racecourse grandstand.

In more recent times Lichfield City Football Club first joined the Birmingham Combination League in 1923 but left after two seasons. The modern-day Lichfield club was established in 1970 and today plays in Division One of the Midland League.

> DID YOU KNOW?
> The first documented cricket match in Lichfield took place in July 1830. The game between Lichfield and Tamworth was played on a large area of open ground called Levett's Field, which was owned by Mr Webb, landlord of the George Hotel and sponsor of the game. Lichfield won the match by twelve runs.

Lichfield Rugby Union Football Club was founded in 1874 and is one of the oldest clubs still active in England. Today the first fifteen play in the Midlands Premier league, a fifth-tier league. The club plays its home matches at Cooke Field, which has been its permanent ground since 1961. Lichfield Ladies is one of the best women's rugby clubs in the country and, in recent times, has produced seven full England international players.

Archery was a popular sport in the city in the eighteenth century. In July 1771, for example, a silver arrow was the prize donated by inventor Richard Lovell Edgeworth in a competition held at the Bowling Green Butts and organised by the Society of Gentlemen Archers. Abraham Hoskins of Shenstone, who was also crowned with a wreath of laurel, won the prize. After the event minuets and country dances were held on the green with many ladies and gentlemen taking part. Lichfield's bowling green has existed on the same site since the 1670s and from at least the 1730s a public house called The Bowling Green has stood next to it. Today both institutions are situated on a large and busy traffic island where roads leading to Birmingham, Walsall and Rugeley meet.

Madame Tussaud's waxwork exhibition turned up in Lichfield in 1831. Highly popular with the Lichfield public, it was held at the city's Theatre Royal in Bore Street. Admittance to the exhibition cost 1s for adults and 6d for children. The wax figures that caused most interest were those of the notorious Edinburgh murderers Burke and Hare, whose trial three years earlier had shocked the nation.

Lichfield's first cinema was the Palladium in Bore Street. It was converted into a cinema from St James's Hall, which had been used as a theatre and concert hall and which in turn had replaced Lichfield's first playhouse, the Theatre Royal, in 1872. The Palladium was renamed the Lido in January 1937. In November 1942 it was badly damaged by a fire but was quickly rebuilt, even though it was wartime, as cinemas were seen as vitally important in helping to keep up public morale. The Lido was reopened in July 1943 and was described in the local press as a 'Super Cinema, Theatre and Café reconstructed on modern lines.' The first film shown in the newly refurbished picture house was the George Formby movie *Get Cracking* described as '95 minutes of fun in the Home Guard'.

Lichfield's other cinema, the Regal, was opened in July 1932, with the first films shown being *The Old Man* and *The Beggar Student*. Built in the art deco style by Birmingham architect Harold Seymour Scott, it had seating for 1,300 customers and also boasted a café. It closed in July 1974 when it became a bingo hall. In the late 1970s the building became a Kwik Save supermarket and a snooker club operated in the defunct café area. For a number of years the once imposing building stood sadly derelict and neglected. Various plans have been put forward to convert the ex-cinema into apartments and very recently demolition of the building took place with a view to preserving its art deco façade.

These days Lichfield's two pools, Minster and Stowe, exist purely for aesthetic and recreational purposes but, in the past, they had different functions. Originally a mill stood at the east end of Stowe Pool and from the thirteenth century the pool was a fishery owned by the Bishop of Lichfield. Samuel Johnson's father, Michael, had a parchment factory

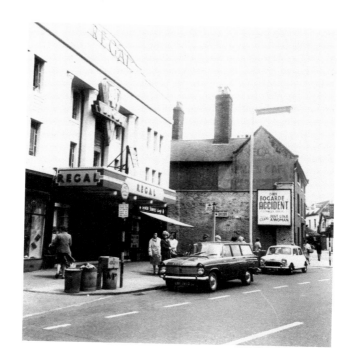

The Regal cinema in its heyday.

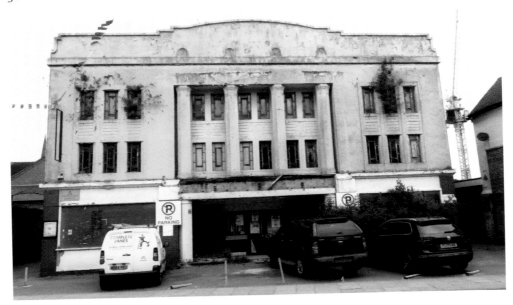

The Regal in recent times.

nearby and the young Sam learned to swim in Stowe Pool and, when the pool was frozen over, enjoyed being dragged barefoot across the ice by his friends. Johnson's willow still stands by Stowe Pool, a descendent of the original tree that was much admired by Johnson as he made the short walk from the city centre to the hamlet of Stowe where his friends Elizabeth Aston and Jane Gastrel resided. In the nineteenth century Stowe Pool was taken over by the South Staffordshire Waterworks Company, was made larger, cleared out and designated as a reservoir to supply water to the Black Country. At the official opening of the scheme in February 1856 a platform was erected at the western end of the pool and a large number of civic dignitaries were invited to be present for the occasion. Unfortunately the platform gave way and collapsed due to the combined weight of those present and it was lucky that no one was seriously injured. In 1968, when it was no longer needed as a reservoir, ownership of Stowe Pool was handed back to Lichfield District Council for use as a public amenity.

Minster Pool was probably created in the eleventh century when sandstone for the first stone cathedral was quarried from the site. A dam was then constructed to create a pond for a mill owned by the bishop in Dam Street. In 1771, following a suggestion made by Lichfield poet Anna Seward, the pool was reshaped to resemble London's Hyde Park's lake, the Serpentine, and a path was laid around its southern bank called New Walk. In 1856 the mill was demolished and Minster Pool also came under the ownership of the South Staffs Waterworks Company. The chairman of the company proposed that the pool should be filled in, saying that it was 'undesirable to have a body of water in the middle of the city where people might throw dead dogs and other unpleasant objects'. However, Lichfield people quickly rejected the idea and so Minster Pool was cleared out instead. Many historical objects were found including a large number of cannonballs that had been used during the Civil War sieges.

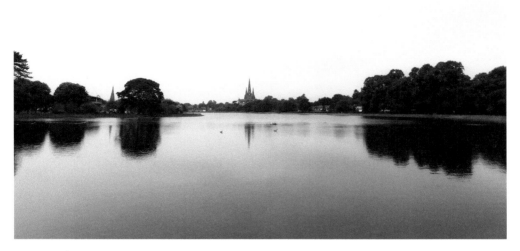

Stowe Pool.

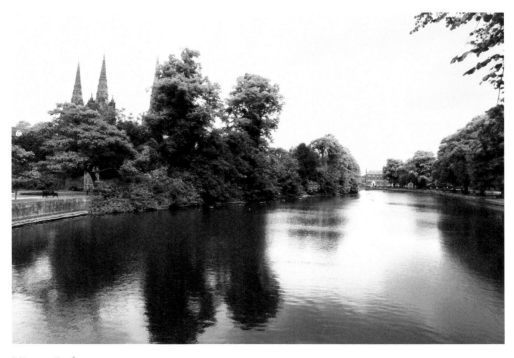

Minster Pool.

8. Writers and Eccentrics

Over the years many famous writers have visited Lichfield and have expressed their opinions about the city. In 1731 Daniel Defoe, the author of *Robinson Crusoe*, found Lichfield to be 'a neat, well built and pretty large city'. However, Horace Walpole, Gothic novelist and son of Britain's first prime minister, described Lichfield's inhabitants to be as 'sleepy as its bishops and canons', and in the 1770s German writer and traveller Karl Philip Moritz formed an even less complimentary view of the city when he wrote that Lichfield had 'narrow dirty streets and the people were unfriendly'. Samuel Johnson, who loved his home town, famously thought that Lichfield was 'a city of Philosophers; we work with our heads, and make the boobies of Birmingham work for us with their hands.' The author Mary Anne Evans, better known as George Eliot, visited Lichfield on a number of occasions, staying at the George Hotel. Although her views on the city were not recorded her uncle, Samuel Evans, on whom she based the character of Seth in her novel *Adam Bede*, resided in Lichfield and in 1860 carved the bishop's throne in the cathedral. Some visitors to Lichfield, however, left an even more lasting impression.

One of these was George Fox (1624–91) the founder of the Society of Friends – commonly known as the Quakers – who was often persecuted and gaoled for his religious views. In 1651 he arrived in Lichfield while travelling the country preaching. Just outside the city, having seen the spires of the cathedral, he seemed to experience a vision. He took off his shoes and walked barefoot into Lichfield where he proceeded to go about the streets and the market square crying, 'woe to the bloody city of Lichfield!' No one quite knows what he was referring to. Was his vision to do with the recent and very violent Civil War sieges of Lichfield? Or was it a reference perhaps to the ancient legend that stated that Lichfield was once the place where Christians had been persecuted and slaughtered in the time of the Roman Emperor Diocletian? Surprisingly, Fox was not arrested by the city's authorities and was allowed to go on his way.

So much has been written about the life of Samuel Johnson that it would be impossible to do the great man justice within the confines of this book so we shall just look at a few anecdotes from the life of arguably the greatest writer of the time, who had been born in the house in Breadmarket Street in 1709 and who went on to compile his famous dictionary.

Johnson was tall and strong despite suffering throughout his life with various illnesses and chronic conditions. On one occasion, when watching a play at Lichfield's Guildhall, he left his seat to visit the toilet only to find on his return someone sitting in it. He asked the man to move and when the person refused Johnson picked up the chair with the man still in it and threw both into the orchestra pit.

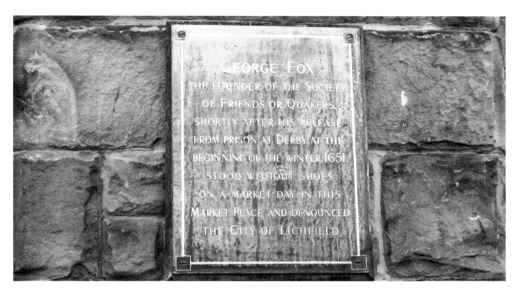

The George Fox plaque in the market square.

DID YOU KNOW?
According to the sixteenth-century historian Leland, St Chad, who brought Christianity to Lichfield and the Anglo-Saxon kingdom of Mercia, would stand on a stone at the bottom of Chad's Well in Stowe praying naked. He would baptise people with the pure water that issued from the well.

According to his friend and biographer James Boswell Johnson had a prodigious appetite and ate an extraordinary amount. According to Boswell's book *The Life of Samuel Johnson*, the good doctor particularly liked pork boiled until it fell off the bone, veal pie with plums and sugar, beef puddings and salted beef. He liked the strongest drink, not for its flavour but for the effect it had on him, and he also liked his drinking chocolate replete with large amounts of cream and even melted butter.

Johnson developed an unlikely friendship with his servant of many years Francis Barber. Barber had been born a slave in Jamaica and, as a young boy, had been brought to England by sugar plantation owner Richard Bathurst, who then gave him his freedom and recommended him as a servant to his friend Sam Johnson. Johnson became very fond of Frank, as he called him, and kept him on as his servant for the rest of his life. When Johnson died he left Frank Barber a large sum of money and some items of furniture in his will. Barber then moved to Lichfield, a place that he had got to know well after accompanying Johnson on his frequent visits to his home city. Frank, with his wife Betsy, lived for a number of years in a house in Stowe Street, spending his time growing vegetables and fishing in Stowe Pool.

Samuel Johnson.

James Boswell.

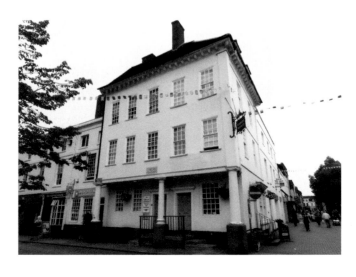

The Samuel Johnson
Birthplace Museum.

Physician Erasmus Darwin lived in a house on the western side of Cathedral Close. Apart from being famous in his own right, he was also the grandfather of the even more famous Charles Darwin, whose work on the theory of evolution was to make him one of the great figures of the Victorian age. Erasmus Darwin moved to Lichfield in 1756 and immediately made a name for himself by curing Mr Inge, a young man with a serious illness, who was expected to die. His medical skills were almost the least of Dr Darwin's incredible range of accomplishments, however. As a scientist he founded the Lichfield Botanical Society and wrote a groundbreaking book on natural history called *Zoonomia*. One of his experiments involved reanimating a dried up and seemingly dead type of small worm called a vorticella. This experiment was actually mentioned in the foreword of Mary Shelley's 1818 novel *Frankenstein*, (although mistakenly and rather amusingly she refers to the reanimated worm as vermicelli, which is a type of pasta). Therefore, it can be said that Darwin, who was a friend of Mary's family, influenced her timeless story about the scientist who was able to restore life back into a corpse.

In 1791 Darwin invented a speaking machine by constructing a head containing a mouth with leather lips and a ribbon stretched between two pieces of wood, which, when blown on, created a sound like the human voice, saying words like 'mama' and 'papa' in

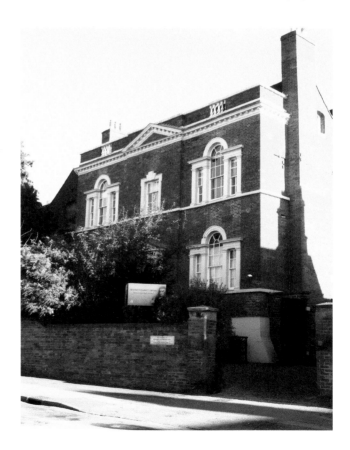

The Erasmus Darwin House.

quite a convincing fashion. Darwin also invented a device for copying handwriting, a horizontal windmill, a carriage that would not tip over and a steering mechanism that, one day, would influence the manufacture of motorcars. Darwin even sketched out ideas for a rocket engine powered by hydrogen and oxygen. As well as all of this Darwin was able to find time to write poetry and take a stance against the slave trade, one of the key political issues of the late eighteenth century.

Darwin is perhaps best known for his involvement with the Lunar Society, a loose collection of thinkers, inventors and writers who would meet each month over food and drink, at the time of the full moon, at Darwin's house or that of his close friend Matthew Boulton in Soho in Birmingham. Industrialist Boulton's business partner, the steam engine pioneer James Watt, was also a member of the group as was the pottery manufacturer Josiah Wedgewood, scientist Joseph Priestley, chemist and geologist James Keir, inventor Richard Lovell Edgeworth and controversial educationalist Thomas Day. The Lunar Society provided an intellectual stimulus to the Industrial Revolution, which was in the process of totally transforming Britain and was why Lichfield could be described as 'a little Athens' by another resident of Cathedral Close, poet and close friend of Dr Darwin Anna Seward. Today a statue of Erasmus Darwin, sculpted by Peter Walker, stands just inside the city's Museum Gardens.

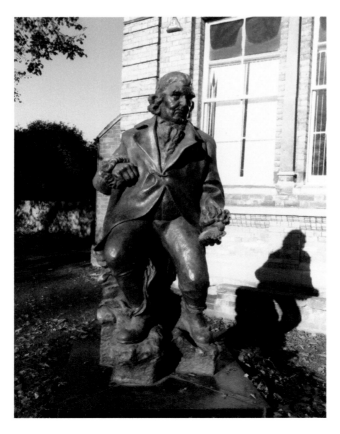

Erasmus Darwin.

Erasmus Darwin and Anna Seward got along famously. Anna once wrote that 'he looks like a butcher and I like a fat cook maid.' Both loved their pet cats. Darwin's was called Snow and Anna gave hers the much more grandiose name of Miss Po Felina. Both would often write about their pets' activities in their letters to friends and relatives. Pets were generally popular among the well off in eighteenth-century Lichfield. Anna Seward also had a dog she called Sappho and her friend and lover John Saville had two dogs, two birds and a frog.

DID YOU KNOW?
Samuel Johnson was born on 18 September 1709. He was a sickly baby suffering from scrofula (a tubercular infection of the lymph glands) and was partially blind and deaf. He later described himself as born 'more dead than alive'. When he was two years old his mother took him to London to be 'touched' by Queen Anne as it was thought that the touch of an anointed monarch could cure afflictions like scrofula.

One of the world's first ever public museums was opened in Lichfield by Richard Greene (1716–93). A friend of Samuel Johnson, Greene's collection of curiosities was sited in Market Street (called Sadler Street at the time), attached to his apothecary shop, and was visited by Dr Johnson in 1776. The collection, which was extremely popular with visitors to Lichfield, included random items such as a Native American wigwam, a stuffed crocodile, gloves once worn by Charles I, a human stomach and kidneys and various artifacts brought back by Captain Cook from the South Seas. Pride of place in the collection was a musical altar clock, which was constructed to look like the tower of a medieval Gothic church. It was sumptuously decorated with angels and other gilded details and played five different tunes including one by the composer Handel. Today the clock is to be found in the Victoria Art Gallery in Bath. Greene was also responsible for putting up the plaque that can still be seen on the building in Dam Street that was the scene of the shooting of Lord Brooke during the first siege of Lichfield in 1643. Following Greene's death his unique collection was subsequently dispersed.

One of the strangest individuals ever to live in Lichfield was Thomas Day. A friend of Erasmus Darwin and fellow member of the Lunar Society, Day would go on to become one of the most popular children's writers of the time with his book *Sandford and Merton*. A follower of the French-Swiss educationalist Jean Jacques Rousseau, Day is best remembered today for an experiment where he applied Rousseau's principles to the education of two young orphan girls with the objective of developing one of them into becoming a 'perfect' wife for himself. Illegally obtaining two girls from orphanages in London and Shrewsbury (he could do this because he was rich and because he was a 'gentlemen') and renaming them Lucretia and Sabrina, he set about teaching them to be stoical and independent from everyone but himself, taking the girls to France where they could not be influenced by

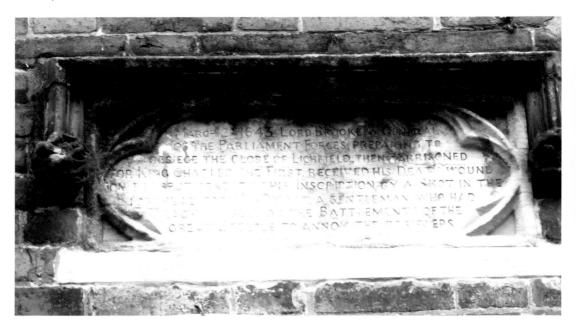

The Brooke House plaque.

others. On returning from France he discarded Lucretia, who he thought was either 'stupid or stubborn', and took Sabrina to Lichfield where he could introduce her to Dr Darwin, Anna Seward and their circles. Day and Sabrina lived in Stowe House where she was expected to do all the cooking and cleaning and where he also subjected her to a number of tests to increase her stoicism. These tests included dropping hot wax on her neck and arm, putting spiders down her dress and firing (unloaded) pistols at her. Day was most put out when she ran off screaming. He also pushed Sabrina fully clothed into Stowe Pool where she was expected to crawl out, weighted down by her heavy and voluminous dress, and then lie down and dry off in whatever sunshine there happened to be. Eventually Day became bored with his 'experiment' and thirteen-year-old Sabrina was packed off to a boarding school in Sutton Coldfield.

Day was not the only eccentric character to have resided in Lichfield. 'Pikelet Poll' lived in Lower Sandford Street in Victorian times and, as her name suggests, sold pikelets (which were similar to crumpets) door to door around the city. By all accounts she was an attractive woman with a very persuasive manner and was insistent that her homemade pikelets only contained the best ingredients. Another eccentric character in Victorian Lichfield was nicknamed 'Betty Bombshell', who carried all of her possessions in a pack upon her back and earned money by scrubbing floors. She was a respectable person but would often be followed around the city by boys who would undo her bundle and strew her belongings around the street. Sadly she ended her days in the Lichfield Workhouse. In more recent times many Lichfield residents will remember an elderly lady called Bertha Frankham, who would be seen around the city pushing a dog in a pram and leading

around numerous other former stray dogs. She lived in a caravan in the Christian Field woods and was a well-liked local character, with many people supplying her with food for her dogs. She died on Christmas Day 1994, apparently at the age of ninety-four.

DID YOU KNOW?
The first Lichfield citizen to be elevated to the peerage was Godfrey Rathbone Benson (1864–1945), who became the 1st Lord Charnwood in 1911. Mayor of Lichfield in 1909 and 1911 and one of the founders of the Johnson Society, he lived for a number of years in Stowe House. He was also internationally famous for his biography of United States President Abraham Lincoln.

Stowe House.

9. War and Peace

When the English Civil War began in 1642 it was soon evident that Lichfield, given its strategic position on the road leading to the main Royalist stronghold of Oxford, would be an important location in the conflict. By March 1643 Cathedral Close, surrounded by its high walls, was occupied by the king's troops and was under siege by the Parliamentary forces commanded by Robert Greville, Lord Brooke. He ordered great cannons to bombard the gates of the Close. One of these was set up in Dam Street with the intention of blasting a hole in the south gate. Brooke, keen to see and assess the damage that was being done, stepped out into the street from the house in which he was sheltering and raised the visor of his helmet to get a clear view. At that moment a Royalist soldier, perched on the roof of the cathedral, saw General Brooke and fired his long-range duck gun at him. Unluckily for Brooke he was hit in the eye either by the bullet itself or a large splinter of wood that flew from the nearby doorframe and he was killed instantly. John Dyott, a member of a well-known local family, had fired the shot. As he was unable to speak he has become known in local legend as 'Dumb' Dyott.

Brooke House.

The Dyotts were also renowned for the strange ritual of holding family funerals at the dead of night. The last of these took place in 1891 when Colonel Richard Dyott, the last in the direct line of the family, died. The torch-lit funeral procession arrived at St Mary's Church in the centre of Lichfield at 10 p.m. on a cold and foggy evening in February. Many people turned out to see the strange sight and at one time the press of locals 'got out of control' and order had to be restored by the police. The funeral progressed according to Dyott family tradition, with no flowers or hymns, as Colonel Dyott's body was laid to rest in the family vault. No one is quite sure why the Dyotts adopted this eccentric practice, although it may date back to the days of Cromwell's Commonwealth when elaborate funerals were discouraged.

Lichfield was no stranger to high-status funerals. In May 1854 shops in the city closed and flags flew at half mast for the funeral of Henry Paget, the 1st Marquis of Anglesey. He had been the second-in-command to the Duke of Wellington at the Battle of Waterloo in 1815, during which he had been badly wounded while helping to direct the battle and needed to have his right leg amputated. Apparently during the operation – carried out in those days without anaesthetic of course – Paget was calm and hardly moved, speaking only to inform the surgeon that his knife did not seem to be very sharp. His amputated leg was buried in the garden of the Belgian house where the operation had taken place with a memorial stone to mark the spot. A few years later Paget revisited the house where his leg had been removed and insisted on being served dinner on the same table on which the amputation had taken place. On the day of Paget's funeral the hearse was pulled by six black horses decorated with black ostrich feathers and was processed through the

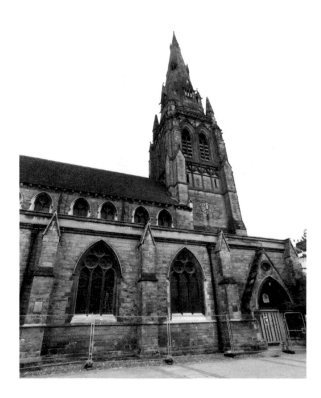

St Mary's Church.

streets of Lichfield, which were lined with people. His body lay in the ballroom of the George Hotel in order to allow locals to file past and pay their respects. The next day, with great ceremony, Paget's body was taken to Lichfield Cathedral, led by a military band playing the 'Funeral March', and interred in the Paget family vault.

DID YOU KNOW?
The first ever edition of the *Lichfield Mercury* was published on 7 July 1815. Its main story was a report on the Battle of Waterloo fought three weeks before and in which allied troops, under the command of the Duke of Wellington, defeated Napoleon's French forces.

1854 was also the year that the ill-fated Charge of the Light Brigade took place at the Battle of Balaclava during the Crimean War. The trumpeter of the 17th Lancers, one of the five cavalry regiments that took part in the charge, was John Brown, who was lucky enough to survive the 'Valley of Death', as Poet Laureate Lord Alfred Tennyson described it. After leaving the army Brown settled in Lichfield, he and his wife living in a house in Wade Street. Unfortunately his army pension was a pittance and he lived the rest

The ballroom of the George.

of his life in poverty, despite concerned locals in his adopted city raising some much needed funds to help him. He died in 1898 and was buried, along with his trumpet, in St Michael's churchyard. Unfortunately the original grave marker was destroyed when a new churchyard path was laid in 1922 but a new memorial stone can now be seen close to the church and war memorial.

Lichfield has long been a garrison town and links with the military have, over the years, usually been respectful and cordial. Many of the city's inns and pubs have memorable connections with the army. The Earl of Lichfield Arms in Conduit Street, for example, has for many years been known by locals as the Drum, a sobriquet that goes back to the time when army recruiters would stand outside the pub banging a drum to attract potential recruits. The King's Head in Bird Street in March 1705 was the site of the founding of the South Staffordshire Regiment by Colonel Luke Lillingston, an event marked by a commemorative plaque on the outside of the building. The South Staffs would go on to see distinguished service in many conflicts over the years including the Peninsular War, the Crimean War and the First and Second World Wars.

On 15 June 1884 an event took place that was to sour relations between Lichfeldians and the military for some time. On that day a number of officers of the Staffordshire Yeomanry, who had assembled in Lichfield for their training week, attended a performance of Gilbert and Sullivan's comic opera *Princess Ida* at the city's St James's Hall in Bore Street. Rather the worse for drink, at the end of the show, some of the officers tried to force their way into the female dressing room. Fighting with the stagehands and theatre manager broke out and soon spilled out into the street where local young men

The grave marker of John Brown.

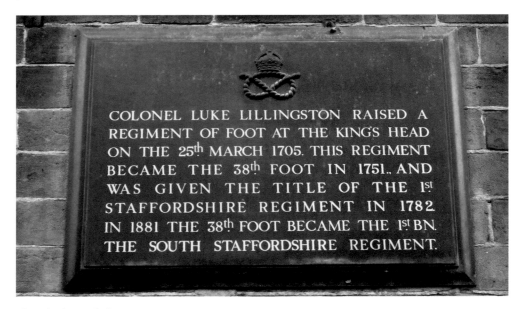

The King's Head plaque.

were quick to join in. During the ugly incident the statue of Johnson in the market square was daubed with boot blacking. The Yeomanry's commanding officer, Lieutenant-Colonel Bromley Davenport, was sent for to quell the riot. However, on his way to the Bore Street brawl Bromley Davenport suffered a heart attack and died. As soon as news of his unfortunate demise became clear the fighting and vandalism died down.

As a military town far from the coast Lichfield was used as a destination for prisoners of war during the Napoleonic Wars of the late eighteenth and early nineteenth centuries. Some seventy-four French prisoners were kept in Lichfield from 1797 including a General Marquet and the Conte de Giborne, who famously lived in a cottage in Cherry Orchard. Another prisoner, Joseph Cato, settled in Lichfield after the war and ran the Three Crowns public house in Breadmarket Street until 1835. In 1961 workmen uncovered a forgotten room to the rear of shops in Bird Street. The circular room was decorated with illustrations including one of Lichfield Cathedral, which were created with pebbles and shells and completed by doubtlessly bored French prisoners who were, at one time, housed there.

DID YOU KNOW?
Prior to the Second World War, on 8 March 1938 Lichfield was the first place in the country to demonstrate a new system for air-raid precautions. The test involved control equipment capable of switching on and off street lights, calling out volunteer firemen and wardens from their homes and sounding sirens in six different areas of the city for alarm and all-clear signals.

10. Royalty and Politics

Over the years many royal personages have visited Lichfield. For example, in April 1346, to celebrate the victorious Battle of Crecy against the French, a great week-long feast was held in Lichfield, which was attended by Edward III. As well as eating and drinking, a tournament was held in the area that is now Beacon Park in which the king tilted with seventeen other famous knights – the flower of English chivalry. Also taking part in the mock fighting, which was watched by a large crowd, was the Prince of Wales, the Black Prince. After the Lichfield visit Edward III, who was always interested in the concept of chivalry, inaugurated the Order of the Garter in 1348.

Another feast took place at Christmas in the year 1397 to coincide with the visit of Richard II. During the celebrations it is recorded that the guests consumed 200 barrels of wine and 2,000 oxen. Shortly afterwards Richard II was again in Lichfield but this time as a prisoner when he was held in a tower at the western end of Cathedral Close in 1399. At one point he escaped by dropping into the moat but was recaptured and taken to his death in Pontefract.

Elizabeth I visited the city in 1575 where she spent a week as part of her tour or 'progress' around the country. In earlier times the monarch would have stayed exclusively in the Cathedral Close but Elizabeth expected to see the whole of Lichfield and so great preparations had been made to spruce up the city. The market square was paved, the market cross was repaired and the Guildhall was refurbished. Roads leading in and out of the city were also improved for the royal visit. The accounts of the bailiffs of Lichfield show that a sum of £5 was paid to a Mr Cartwright for making a speech and another, more mysterious payment, was made to William Hollcraft for 'kepynge madde Richard when her majestie was here'.

DID YOU KNOW?
In November 1745 the Duke of Cumberland, who was on his way to Scotland to put down the Jacobite Rebellion, stayed at the Swan Hotel in Bird Street, while his army camped outside Lichfield. The duke, the younger son of George II, and his staff dined at the Swan and consumed large amounts of beef, bacon, veal, pigs' ears and feet and a calf's head. The meal cost £10 13s, a considerable amount of money at the time. Cumberland went on to put down the rebellion with great ferocity and earned himself the nickname of 'Butcher Cumberland'.

Some royal visits were not undertaken for friendly reasons. In 1643 Charles I's nephew, the twenty-four-year-old Prince Rupert of the Rhine, came to Lichfield during the Civil War with orders to recapture the cathedral from Parliamentary forces. In the second siege of Lichfield Rupert's artillery bombarded the cathedral from some high ground to the north of the cathedral's fortified walls. From the hill, still today called Prince Rupert's Mound and now part of the beer garden of the George & Dragon pub in Beacon Street, hundreds of cannonballs were fired at the defenders. Rupert also used miners from Cannock to dig tunnels and explode gunpowder under the walls in an attempt to bring them down. The Parliamentarians surrendered the next day and the cathedral fell back into Royalist hands, only to be recaptured again three years later.

In 1832 the twelve-year-old Princess Victoria visited Lichfield. Already being described in the *Lichfield Mercury* as 'the future Queen of England', she was accompanied by her mother, the Duchess of Kent. Large crowds greeted the young princess as she first visited the cathedral and then attended a reception at the Guildhall. Victoria's appearance was commented on in the *Mercury*, which described the princess as having a 'frank and good-humoured countenance' and 'whose features bear a degree of resemblance to the lamented Princess Charlotte' (the daughter of George IV who had died in childbirth at the age of twenty-one). Victoria's complexion was said to be 'delicate' and she was described as being 'dressed in an extremely simple style with braided hair formed into a small plaited coronet at the top of her head'. Victoria was to visit Lichfield again, this time as queen, in

Prince Rupert's Mound...

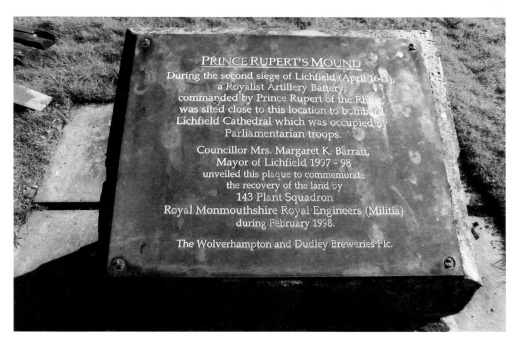

PRINCE RUPERT'S MOUND
During the second siege of Lichfield (April 1643),
a Royalist Artillery Battery,
commanded by Prince Rupert of the Rhine,
was sited close to this location to bombard
Lichfield Cathedral which was occupied by
Parliamentarian troops.

Councillor Mrs. Margaret K. Barratt,
Mayor of Lichfield 1997 - 98
unveiled this plaque to commemorate
the recovery of the land by
143 Plant Squadron
Royal Monmouthshire Royal Engineers (Militia)
during February 1998.

The Wolverhampton and Dudley Breweries Plc.

...and commemorative sign.

December 1843 when she and her new husband, Albert, were staying at Drayton Manor, the home of Prime Minister Robert Peel. The queen was cheered as she rode through the streets of Lichfield in the state coach pulled by four grey horses.

Victoria's son, Edward VII, visited Lichfield in 1894 when he was the Prince of Wales. His accession to the throne was commemorated in the city with the unveiling, in 1908, of a statue of the king in his coronation robes, which still takes pride of place in Lichfield's Museum Gardens.

On the front of the Guildhall in Bore Street busts of George V and Queen Mary can be found, which were placed there to celebrate the king's accession to the throne in 1910. Local benefactor Colonel Swinfen-Broun presented the nearby clock to the city in 1928. Queen Mary visited the city on her own in 1927. Despite the visit being described as a private one, details had become generally known and large crowds were there to welcome the royal personage. Queen Mary visited the cathedral and was particularly interested in the statue of *The Sleeping Children* and also spent time in the cathedral's war memorial chapel.

During the height of the Second World War George VI and Queen Elizabeth visited Lichfield. Thousands of people filled the streets on 16 July 1942 to greet the royal couple, who were visiting the city for the first time. The crowds were made up not only of local people but also of American Army nurses and United States and Australian soldiers. The king and queen were shown around the cathedral by the Bishop of Lichfield before walking through the thickly lined streets to the Johnson Birthplace, which they toured before leaving on the royal train from Trent Valley station.

Parliamentary elections in the past were long drawn-out affairs and in the eighteenth and nineteenth centuries, before secret polling was introduced, were quite often corrupt. The 1799 poll in Lichfield, for example, lasted for nine days but only 525 people voted, giving some indication of how limited the franchise was in those times. At the end of each

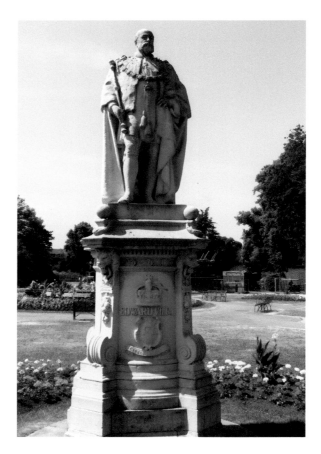

Edward VII.

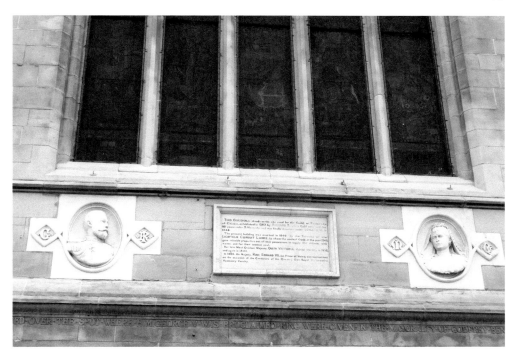

Guildhall detail.

The nearby clock.

day's voting a notice was posted to show how the votes were being cast. In an election in 1771 the candidates' election expenses included £142 spent on treating individuals to drinks in local hostelries, after which the intoxicated voters would be led to the polling station, often accompanied by musicians. Elections were also frequently the cause for unruly behaviour in the city. During the 1826 election the windows of the George Hotel were smashed by a mob that formed outside in Bird Street. The situation became so serious that the military were sent for to quell the rioting. Disturbances like this in the city were exacerbated by the fact that the headquarters of the two political parties of the time stood opposite each other on either side of Bird Street. Traditionally the Whigs used the George as their centre of operations while the Tories met in the Swan. Following the election of 1831 the two victorious Whig Members of Parliament and their supporters celebrated in the George, toasting the promised Parliamentary Reform. However, even after the 1832 Great Reform Act Lichfield was still allowed to send two MPs to Parliament and it was not until 1868 that the number was reduced to one. In the 1895 election violence broke out again when forty men from Walsall, sporting Tory colours, threw rotten fruit and manure at Whig supporters on general election day and were subsequently charged with disturbing the peace.

The Swan.

11. Matters of the Heart

The writer Anna Seward, known as the 'Swan of Lichfield' and who was an internationally renowned poet in her day, shocked her fellow residents of Cathedral Close when she conducted an affair with a married man. Anna, who lived most of her life in the city, resided with her parents at the Bishop's Palace. Her father, Thomas Seward, was canon residentiary of the cathedral and he had moved with his family in 1750 from Derbyshire when his daughter was seven years old. Anna, forthright in her opinions, an unusual trait in a woman in the eighteenth century, was never to marry but her affair with John Saville, vicar choral of the cathedral, was to last over thirty years. The scandal reached a climax in 1773 when Saville left his wife and two daughters and moved into an adjoining one-bedroom house. Anna adored Saville, who she called 'il penseroso' ('the serious man'), and although her neighbours turned a blind eye to the goings on they never approved of the situation. When Saville died unexpectedly in August 1803 Anna commissioned, at great cost, a large memorial in the cathedral and also generously ensured that Saville's wife and family were financially secure.

When Anna died in March 1809 her friend, the novelist Sir Walter Scott, edited her poetical works in three volumes and her letters were also published soon afterwards in six volumes. These were particularly popular with those expecting some great revelations about Anna's love life, although readers were to remain disappointed on that score. It was Scott who also provided the verse for Anna's large and ornate memorial plaque in the cathedral.

Anna was connected to another of Lichfield's tragic love stories. Honora Sneyd lived with the Seward family in the Bishop's Palace from 1757. Honora was a member of a long-established and wealthy Staffordshire family whose original home had been Keele Hall in the north of the county. When Honora was five years old her mother died and her father, army officer Edward Sneyd, asked his various friends and relatives to look after his eight young children. Anna Seward became very fond of Honora, who grew up into a very beautiful, willowy and angelic-looking young woman. Anna was very keen for Honora to wed someone who was of an artistic and sensitive temperament and so was very pleased when, in 1769, a poetical young London clerk called John André, who was an accomplished artist, courted and later, encouraged by Anna, became engaged to the seventeen-year-old Honora. The romance continued for around eighteen months before the Sewards, along with Major Sneyd, decided to call off the engagement. They had decided that John, as a mere clerk, albeit in his own family business, was not on an equal social standing with Honora. People in the eighteenth century were highly status and class conscious and a merchant – despite André being a comparatively wealthy one – was not considered to be a suitable match for the daughter of a military man whose foster parents were of a high-status clerical family. John André went away saddened and decided

Sacred to the Memory
of
JOHN SAVILLE,
48 Years Vicar-Choral of this Cathedral.
Ob: Aug.ᵗʰ 2ᵗʰ 1803. Æta: 67.

Once in the Heart, cold in yon narrow cell,
Did each mild grace, each ardent virtue dwell;
Kind aid, kind tears for other's want and woe,
For other's joy, the gratulating glow;
And skill to mark, and eloquence to claim
For genius in each art, the palm of fame.
Ye choral Walls, ye loft the matchlels song
When the laft filence ftiffen'd on that tongue,
Ah! who may now your pealing anthems raife
In foul-pour'd tones of fervent prayer and praife?
Saville, thy lips, twice on thy final day,
Here breath'd in health and hope the sacred lay:
Short pangs, ere night, their fatal fignal gave,
Quench'd the bright Sun for thee and op'd the Grave!
Now from that graceful form and beaming face
Infatiate worms the lingering likenefs chafe,
But thy pure Spirit fled from pains and fears
To finlefs-changelefs-everlafting Spheres.
Sleep then, pale mortal Frame, in yon low fhrine
"Till Angels wake thee with a note like thine?"

Left: The memorial to
John Saville in the cathedral.

Below: The Anna Seward
memorial, Lichfield
Cathedral.

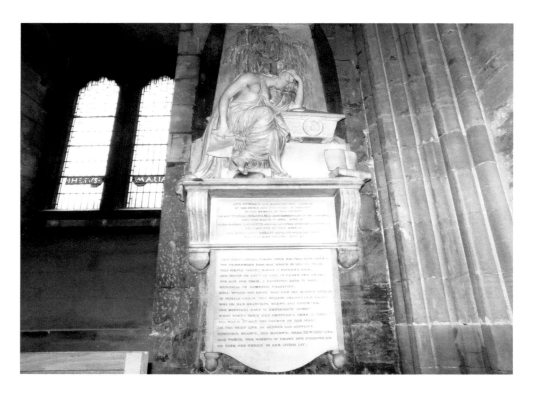

to buy a commission into the army, perhaps working on the belief that being an army officer would enable him to be considered more of a 'gentleman', in eighteenth-century terms. John's subsequent rise through the military ranks was exceptional. By 1780 he was Major André and in charge of military intelligence in New York during the American War of Independence. One of his main roles was to try and persuade American army officers to switch to the British side. It was while he was arranging for the defection of top-ranking American war hero General Benedict Arnold and the surrender of West Point fort that André was captured, tried as a spy and hanged at Tappan, near New York. He was just thirty years old. It is interesting to speculate that had André's plan succeeded and the important strategic stronghold of West Point been handed over to the British it is possible that the Americans would have been defeated in the war and the United States would never have come into existence. Anna Seward's long poem about her friend, 'Monody on the Death of Major Andre', was hugely popular at the time and André was mourned across the country, being regarded as a national hero.

Honora went on to have many other suitors including the eccentric and controversial writer Thomas Day, who she rejected. However, she did fall for Day's friend, inventor, landowner and fellow member of the Lunar Society Richard Lovell Edgeworth. Just four months after the death of his first wife Edgeworth proposed to Honora. It was accepted and they were married in July 1773 in Lichfield Cathedral. The couple moved to Ireland where Edgeworth had large estates. One day Honora was in the field chatting

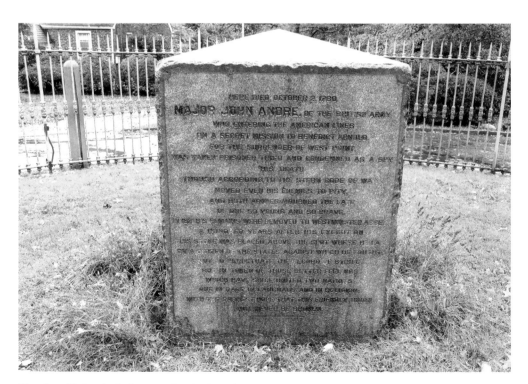

The site of John André's execution in America.

to her husband's farm labourers when her wedding ring slipped from her finger. She ordered the forty men to search for the lost ring and when it was found she vowed that she would never remove the ring while she was alive. In 1779 the delicate Honora fell ill and Edgeworth took her back to Lichfield to see his friend Dr Erasmus Darwin. Honora was diagnosed with tuberculosis, a deadly disease in the eighteenth century and one that would take the lives of many young men and women at the time. The devastated Edgeworth took Honora to a house on the Weston estate, which was owned by his friends Sir Henry and Lady Bridgeman. There, racked by a painful cough, Honora grew steadily worse until, on 1 May 1780, she died. Her husband was with her and as she breathed her last he noticed something fall to the floor. Looking down he realised that her wedding ring had slid from her emaciated finger and he remembered her vow from a few years before. The tragic Honora was buried in St Andrew's Church on the Weston estate.

By all accounts Edgeworth was devastated by Honora's death but it did not stop him returning to Lichfield and quickly proposing marriage to her sister, Elizabeth. She accepted and the couple married just seven months after Honora's death. The wedding was actually illegal under church law and the Revd Seward refused to marry the couple in Lichfield and so a simple service took place in London on Christmas Day 1780. The new Mr and Mrs Edgeworth would go on to have nine children before Elizabeth died in 1797. Edgeworth, who would marry once more, eventually had a total of twenty children including Maria Edgeworth, who became a well-known novelist.

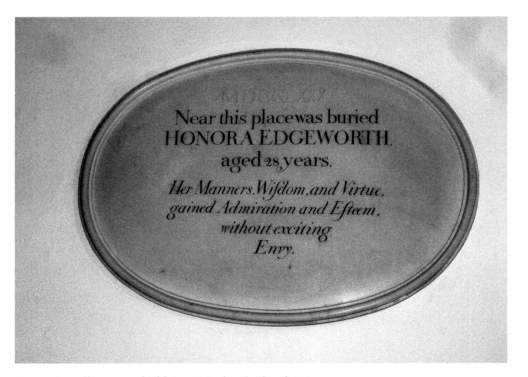

Honora Sneyd's memorial tablet in St Andrew's Church, Weston.

DID YOU KNOW?
William Dyott, a member of the old Lichfield family who lived at Freeford Hall, had a rather strange relationship with his wife. In his diary, which he kept from 1781 until his death in 1847, he first writes fondly of a wife he apparently adores but then chronicles the breakdown of his marriage. His wife, Eleanor, became an invalid and then eloped with a man called Dunne. A special Act of Parliament was required in those days to enable Dyott to divorce his estranged spouse.

An equally tragic story concerns Lichfield woman Ellen-Jane Robinson. Born Ellen-Jane Woodhouse in Donnington, Shropshire, in July 1783, her mother was the interestingly named Mercy Peate and her father, born in Lichfield in 1749, was John Chappell Woodhouse, who became Dean of Lichfield Cathedral in 1807. In April 1801 Ellen-Jane married the Revd William Robinson, a prebendary of the cathedral. The couple soon had two daughters, Ellen Jane and Marianne. In 1812 the first of many disasters struck the young family when William Robinson died of tuberculosis and Ellen-Jane was left with the two girls to bring up alone. Soon afterwards, while in Bath in 1813, Ellen-Jane, her eldest daughter, died from burns received after her nightdress burst into flames when she got too near to the fire in the hearth as she was preparing to go to bed. The following year, tragically, Mrs Robinson's youngest daughter, Marianne, also contracted tuberculosis and was quickly carried off by the disease. Understandably consumed by grief, Ellen-Jane Robinson wanted to commemorate the lives of her two daughters and so commissioned Sir Francis Chantrey, the most accomplished British sculptor of the age, to create a fitting statue. Ellen-Jane told Chantrey that she loved to watch her two girls fall asleep in each other's arms and that was how she wanted the children depicted. Chantrey exhibited his statue first at the Royal Academy, where it was soon labelled a masterpiece, and then it was placed in the south-east corner of Lichfield Cathedral in 1817 where it remains to this day. The memorial, entitled *The Sleeping Children,* has been a favourite with visitors to the cathedral ever since. It is made from white marble and depicts the two girls as they lie asleep in each other's arms with Marianne holding a small bunch of snowdrops in her hand. Above the statue is a memorial tablet to William Robinson, the girls' father.

Ellen-Jane Robinson married again, this time to Hugh Dyke Acland in June 1817. They were to have one child, also called Hugh Acland, the following year. Her second husband died in 1834 at the age of forty-three. Ellen-Jane married for a third time in 1835 to Richard Hinckley, who she was also destined to outlive. As a result of this marriage she moved into Beacon Place, a late eighteenth-century mansion in Lichfield that had an almost 100-acre estate attached. In 1847 the Hinckleys donated an acre or so of their land for the construction of a new church, Christ Church, which was built in the Gothic Revival style by Lichfield architect Thomas Johnson. Ellen-Jane was unfortunately able to bury both her son, in 1851, and her third husband, in 1865, in the new churchyard behind Beacon Place. Ellen-Jane's own long and tragic life came to an end in 1870. She was aged

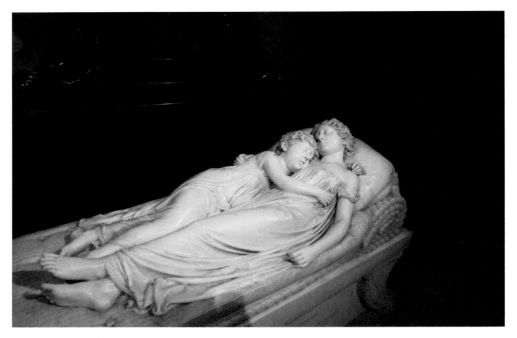

The Sleeping Children.

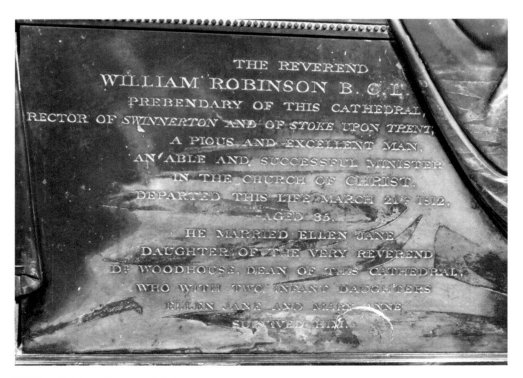

THE REVEREND
WILLIAM ROBINSON B.C.L.
PREBENDARY OF THIS CATHEDRAL,
RECTOR OF *SWINNERTON* AND OF *STOKE* UPON *TRENT*,
A PIOUS AND EXCELLENT MAN,
AN ABLE AND SUCCESSFUL MINISTER
IN THE CHURCH OF CHRIST,
DEPARTED THIS LIFE MARCH 21st 1812,
AGED 35.
HE MARRIED ELLEN JANE
DAUGHTER OF THE VERY REVEREND
Dr WOODHOUSE, DEAN OF THIS CATHEDRAL,
WHO WITH TWO INFANT DAUGHTERS
ELLEN JANE AND MARY ANNE
SURVIVED HIM.

William Robinson's memorial plaque.

Christ Church.

eighty-seven and her large stone tomb is situated outside the south side of Christ Church next to those of her third husband and their son.

Another heartfelt memorial can be found in the churchyard of St Michael's on Greenhill. James Thomas Law was born in 1790, the son of the Bishop of Bath and Wells. He became chancellor of the diocese of Lichfield in 1821 and among many other roles he was also the master of St John's Hospital in the city. In 1866 his wife, Henrietta, died and so Law, keen to mark the death of his beloved in a monumental way, had a grand canopied mausoleum built in the Medieval Gothic style of the age. The building, which today has Grade II-listed status, is to be found on the northern edge of the vast churchyard adjacent to the Trent Valley road. The tomb was adorned with a clock with two faces, illuminated at night by gas lamps and was there to give a reminder of the time to those travellers heading to and from Lichfield Trent Valley station and also, one imagines, to make the massive mausoleum even more noticeable. Sadly the clock is now missing, having disappeared many years ago, but the tomb still stands as a memorial to one man's love for his departed wife.

84

DID YOU KNOW?
In 1872 Lichfield woman Sophia Lonsdale, like all eighteen-year-old females from wealthy backgrounds at the time, was launched into society at the County Ball held at the city's Guildhall. There she danced the night away with a collection of admiring young men, and although she disliked the venue, she described the ball as 'excellent'. Sophia, who would later become a social reformer of some importance, had strikingly good looks, being 5 feet 9 inches tall, with a commanding presence and piercing brown eyes, eventually decided not to marry and stayed single for her entire life.

The mausoleum of John and Henrietta Law.

12. Treading the Boards

The theatre has had a long history in Lichfield. In medieval times plays would be performed in the courtyards of taverns and inns. By the eighteenth century plays were being presented in the Guildhall in Bore Street. One such was advertised in the *Birmingham Gazette* in January 1767. As was the fashion of the day two plays were put on, which were sponsored by the Countess of Donegal, who had a town house next to the Guildhall. The plays were a comedy called *The Conscious Lovers* and a farce entitled *The Deuce is in Him* and they were put on by an acting troupe called Durravans and Company. Between the various acts of the dramas other delights such as songs and conjuring were also presented. The entertainments began at six o'clock each evening and the packed programme would go on for many hours.

The greatest actor of the Georgian age was from Lichfield. Although born in Hereford in February 1717, David Garrick always considered Lichfield to be his home. He and his family lived in a house in Beacon Street opposite the entrance to Cathedral Close. The house itself has long since gone but a plaque on the present building marks its spot.

The site of the Garrick family's home in Beacon Street.

Garrick attended Lichfield Grammar School and later was enrolled at Samuel Johnson's ill-fated school at Edial where he and the great doctor developed a lifelong friendship. In 1737 both men decided to seek their fortunes in London. Having little money and only one horse between them they travelled to the capital using the 'ride and tie' method where one would ride the horse for a while before tying the animal to a tree and walking on. The other would then walk to the tethered horse and ride it for a while repeating the process for the other person. In London, Garrick first began to study the law and when that failed he tried his hand as a wine merchant. However, his first love since a child had been the theatre and within a remarkably short time he became the best-known actor in the country. Such was his popularity that stagecoach trips were organised from his home city to enable Lichfeldians to see the local lad act in plays like *Richard III* and *Cymbeline*. Garrick brought huge innovations to the stage and was instrumental in changing the style of stagecraft to a more natural and realistic approach. For the first time Garrick made acting a reputable profession and when he died in 1779 he was the first actor to be granted a burial in Westminster Abbey.

DID YOU KNOW?
Lichfield-born actress Sian Brooke was actually born Sian Phillips. To avoid confusion with the already well-known actress Sian Phillips, she changed her name and chose the name Brooke from the Civil War general who had been shot and killed in Dam Street during the Civil War siege of Lichfield in 1643.

In Lichfield two theatres have been named after the great actor. The first opened in 1949 and was called the David Garrick Memorial Theatre. It was situated in Bore Street where the Wilko's store now stands and was originally called St James's Hall and then the Palladium cinema. However, the theatre only lasted until 1953 when it closed after funding issues. For a short time in 1949 Kenneth Tynan, straight out of university, worked at Lichfield's David Garrick Memorial Theatre, the youngest professional director in the country. In the years to come Tynan, who was born in Birmingham in 1927, was to be become one of the most controversial characters in the British theatre establishment. He was also to attain a special notoriety in 1965 when he became the first person on British television to use the 'f' word on live TV.

Today another Garrick theatre stands in the city. Opened in 2003, its first production was *The Recruiting Officer* by George Farquhar. It was a fitting play to open with as the author, a recruiting officer for the army, had written it while staying at the George Hotel in the early eighteenth century. It was also the first play acted in by a twelve-year-old David Garrick in a production at Lichfield's Bishop's Palace. The second production at the newly opened Lichfield Garrick was, appropriately, about Lichfield's most famous son, Samuel Johnson, and his long-time servant Francis Barber. The play, entitled *Resurrection*, was written by Maureen Lawrence and starred the actor Corin Redgrave as Dr Johnson.

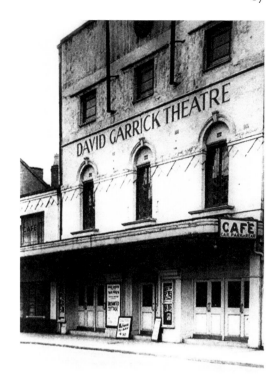

Right: The original Garrick Memorial Theatre in Bore Street...

Below: ...now the site of a Wilkinson's store.

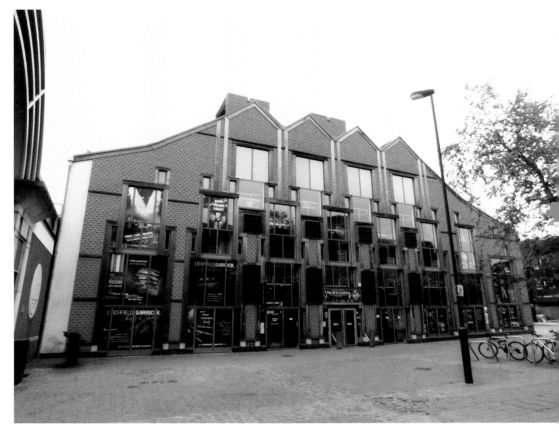

Today's Lichfield Garrick.

Another play by George Farquhar, *The Beaux Stratagem*, is actually set in Lichfield. A comedy, it contains such characters as Lady Bountiful, who lives at the Bishop's Palace; Boniface, the landlord of the George Inn; Scrub, a servant; and Gibbet, a highwayman. Surprisingly the play was not performed professionally in Lichfield until 1949 when Kenneth Tynan oversaw a controversial production of Farquhar's work.

Surprisingly three further Lichfeldians have followed in the footsteps of David Garrick and have become stars of the stage and screen. Helen Baxendale became internationally famous when she played the role of Emily in the US television series *Friends;* Sian Brooke became very well known for her appearances in *Sherlock,* where she played the part of the detective's mysterious sister; and Pamela Binns, who started out at the original Garrick theatre in 1949, has had a long career on stage, television and in films, appearing with many of the big names of acting like Michael Caine, Sean Connery and Roger Moore.

One of the first productions at the new Lichfield Garrick.

DID YOU KNOW?
George Farquhar's play *The Recruiting Officer* was performed in Lichfield in March 1770 by Mr Kemble's company, probably at the city's Guildhall. Mr Kemble played Sergeant Kite and Mr Siddons played the part of Mr Worthy. Mr Siddons was married to Mr Kemble's daughter Sarah, who, as Sarah Siddons, became the leading actress of the day.

13. Things That Go Bump in the Night

In a city that contains so many ancient buildings, it is inevitable that some would have ghost stories attached to them.

The King's Head in Bird Street is one of Lichfield's oldest and most popular pubs. Originally called The Antelope, it received its present name in the seventeenth century, although it is not known which king the name refers to. One of a number of ghost stories associated with the King's Head is that of a laughing cavalier. This is supposedly the ghost of a royalist soldier who was hacked to death in the street outside the pub during the Civil War in the 1640s. After he was killed his body, for some reason, was dumped in the cellar of the pub. Over the years a number of people have claimed to witness the ghost of the cavalier in the pub and in the street outside where, despite his visible and gory wounds, he still manages to exhibit a cheery disposition. The ghost of a small girl who apparently died in a fire at some point in the distant past also purportedly haunts the pub. People

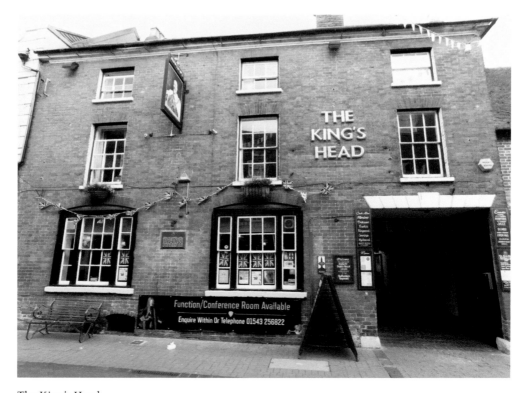

The King's Head.

have said that at times the girl can be seen in one of the windows of the King's Head holding a flickering candle and looking forlorn. At least one of the recent landlords, Sid Farmer, was convinced that he saw the spectre of the girl on a number of occasions. A third restless spirit, christened George by staff at the pub, is said to be the ghost of a former landlord who died of a heart attack while working in the cellar.

Another cavalier ghost was said to have haunted the Precentor's House in Cathedral Close. According to the writer and social reformer Sophia Lonsdale, whose parents lived in the building in the 1840s, the parlour maid, while turning down a bed, saw the ghost of a long-haired man wearing a hat with feathers. The maid was so traumatised by the event that she begged not to have to go into the bedroom again. Sophia Lonsdale also lived at one time in the Chancellor's House in Cathedral Close and, according to her memoirs, her mother and two of her sisters regularly saw the spirit of a woman in a red shawl appear in the house's drawing room. The ghost would sometimes issue a loud sigh and also occasionally kicked the family's pet dog, which understandably was terrified of the spectre.

In Bird Street, not far from the King's Head stood a furniture shop where the ghost of another young girl was seen on at least two occasions. In 1986 a carpet fitter rapidly retreated from what he knew to be an empty shop after the girl appeared apparently staring straight at him. The man, who by all accounts was a sensible chap and not given

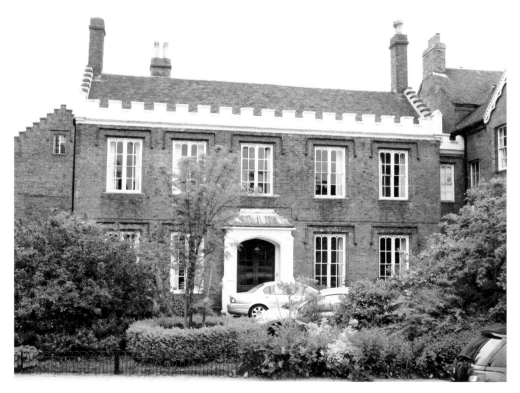

The Precentor's House, Cathedral Close.

to flights of fancy, could not be persuaded to be in the empty shop again. A few years later in 1991 a cleaner vacuuming an upstairs room noticed a sudden drop in temperature followed by the appearance of a girl, aged around thirteen, looking extremely sad and wearing a bonnet and shawl. The cleaner heard the voice of the girl in her head telling her that her name was Elspeth and the room had, at one time, been her own.

DID YOU KNOW?
In 1771 Anna Seward took the young John André to visit two of her friends called Cunningham and Newton. On seeing John for the first time Cunningham looked shocked and set about relating a dream he had had the night before in which he was walking in a strange city and witnessed a man being hanged. When Anna appeared with John he immediately recognised him as the hanged man in his dream. In 1780 John André was hanged in America after being convicted of spying.

The Acorn public house (now called the Pig & Truffle) in Tamworth Street is another old drinking establishment that boasts a resident ghost. In 1972 a newly appointed barmaid at the pub attempted to serve a customer, who was dressed entirely in black and who preceded to disappear in front of her eyes. Unnerved by the experience, she reported it to the landlord, who informed her that the apparition had been seen by a number of regulars over the years. So frequent were the spectre's appearances that he was christened Fred and could often be seen sitting in the corner reading a newspaper. The ghost, according to the landlord, occasionally made a nuisance of himself, sometimes throwing glasses at the pub's employees.

At the Scales Inn in Market Street two people who worked at the pub in the late 1970s and early 1980s separately observed, in the cellar, a headless woman in a black gown with a white collar and cuffs. Both reported that the figure disappeared through the cellar wall accompanied by an unnaturally deeply cold atmosphere. The pub's dog, according to the landlady at the time, would never go down into the cellar and would occasionally howl for no apparent reason.

W. E. Pead, manager of the Lichfield Brewery in the early years of the twentieth century, wrote in his diary about the ghost of Freeford Hall, the ancestral home of the Dyott family. During the First World War Pead's wife worked at the hall as a volunteer when it was being used as a hospital for wounded soldiers. The ghost, seen by a number of nurses at the time, was said to be the spirit of former housekeeper Mrs Rawlings.

Yeomanry House once stood in St John Street opposite St John's Hospital, where a garage and car showroom were later built. At one time it was the site of the high school for girls, the forerunner of the Friary School. A number of the girl boarders at the school once asked the headmistress, Miss Hawkins, if they could see the baby that they could hear crying each night. The headmistress told the girls that there was no baby in the building and they must have heard a cat making noises in the night. A little later someone

The former Acorn public house.

The Scales public house.

who knew a little of the history of Yeomanry House told Miss Hawkins that some years before, when the building was a private residence, a servant girl had murdered her baby there. Later residents, Captain Webster of the Staffordshire Yeomanry and his wife, also reported hearing the ghostly crying of the baby. Yeomanry House was demolished in 1925 when, hopefully, the unquiet spirit of a newborn, murdered child was also laid to rest.

The spectre of an elderly man dressed in black has apparently appeared on a number of occasions to staff working at the Erasmus Darwin Museum in Beacon Street. It is claimed that the ghost has regularly been seen at the top of the house's landing and

more intriguingly witnessed by some to have been seen crossing the road outside before vanishing into thin air. In other incidents doors have opened and closed of their own accord and laughing children have been heard, presumably when none have actually been present.

DID YOU KNOW?
On 28 October 1950 people claimed to have witnessed a flying saucer over Lichfield. The unidentified flying object was observed by a number of individuals, who described it as a disc, slightly smaller than the moon, flying at the speed of a jet plane and emitting a low droning noise. However, one local resident suggested in the local newspaper that it was most likely a secret aircraft being tested by the military.

Donegal House, which at one time was the town house of the Marquis of Donegal, stands next to the Guildhall in Lichfield and was once the home of the city's tourist information centre. Several years ago someone working in the building noticed two young girls seemingly dressed in nineteenth-century costumes. He turned to his colleague, pointing out the two children and asked if there was some sort of fancy dress party going on. His fellow worker was nonplussed, as not only was he unaware of any fancy dress event but also could see no girls at all. Later the man's own researches seemed to indicate that many years before two girls living at Donegal House were burned to death while attending a birthday party elsewhere in the city.

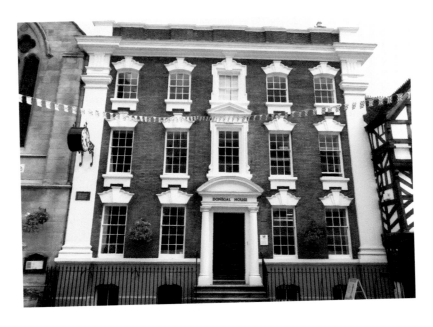

Donegal House.

Select Bibliography

Clayton, Howard, *Coaching City: A Glimpse of Georgian Lichfield* (Lichfield, 1970)

Clayton, Howard, *Mr Lomax's Lichfield* (Lichfield, 1991)

Coley, Neil, *The Beauty and the Spy: Georgian Lichfield and the Tragic Story of John Andre and Honora Sneyd* (The Lichfield Press, 2016)

Hopkins, Mary Alden, *Dr Johnson's Lichfield* (New York: Hastings House, 1952)

Knibb, Joss Musgrove, *Lichfield in 50 Buildings* (Stroud: Amberley Publishing, 2016)

Martineau, Violet, (ed.) *Recollections of Sophia Lonsdale* (London: John Murray, 1936)

Rubery, Annette, *Lichfield Then and Now* (Stroud: Amberley Publishing, 2012)

Shaw, John, *Street Names of Lichfield* (Lichfield, 2003)

Upton, Chris, *A History of Lichfield* (Chichester: Philimore & Co. Ltd, 2001)

The Lichfield Mercury

The websites Lichfield Lore and Lichfield Live.

Acknowledgements

The author and the publisher would like to thank the authorities of Lichfield Cathedral for allowing the taking of photographs in the cathedral and around Cathedral Close. The majority of the photographs in this book were taken by the author, who would like to thank Dave Gallagher and the Facebook group You're probably from Lichfield Staffs... for the historic photographs of the Garrick Memorial Theatre and the Regal cinema. We would also like to thank Robert Yardley and the St Mary's Heritage Centre for giving permission to use the other images of old Lichfield in this book.

I would like to thank my wife, Sue, for her proofreading skills and her invaluable and constant love and support.

About the Author

Neil Coley first moved to Lichfield in 1974. He is the author of five other books: *Lichfield Stories, The Lichfield Book of Days, The Beauty and the Spy: The Tragic Story of Honora Sneyd and John André, Lichfield Pubs* and *Lichfield People.*